MEXICAN AMERICAN BASEBALL IN THE POMONA VALLEY

Las beisbolitas
by Claudia Rodriguez

They played in fields
smaller than the men's,
right before the men hit the lots.
These mujeres were no warm up acts!
Across the Southwest, las Tomboys, Aztecas,
Rock-etts y las Moreloettes,
traded their aprons for a chest protector
y un bat. Not torteando tortillas on Sunday,
punching their glove-pocket
ready for the heat of the grounder.

Las beisbolitas
took me down memory lane.
My little arm hooked around my Ama's elbow
walking safely down the street.
Little arm that could throw a ball fast,
directly at a bully's right calf.
"Don't tell me girls can't play ball!
Next one will be a homerun. I call right field."

Mujeres beisbolistas?
They did it for the fun, the winning,
the friendships and the aches.
Filled many fields with their dreams
with each round of the bases.
Las beisbolistas broke
racist, gendered barriers one crack
of the bat at a time to
play Béisbol the game they loved.

—

Claudia Rodriguez is a writer/performer from Compton. Her first collection of poetry, Everybody's Bread, *is forthcoming summer 2014 by Korima Press.*

FRONT COVER: Richard Peña was born in 1930 in East Los Angeles, California. Richard is the youngest of the famous nine Peña baseball brothers coached by their father. He is shown here at 16 pitching for an American Legion team. He was an outstanding player at Roosevelt High School and played professionally in the United States and Mexico. (Courtesy of Richard Peña.)

COVER BACKGROUND: The 1959 Cucamonga District Little League El Cinco De Mayo team won the league championship posting an 18-2 record. Over a 10-year period, the team's winning percentage was nearly .800, and the team never finished lower than second place. The manager was Alfonso Ledesma, who has dedicated his life to youth sports in the area. (Courtesy of Alfonso Ledesma.)

BACK COVER: The Sunkist Oranges team was comprised of players from Claremont, many who were outstanding players in the 1940s and 1950s. Most of the families that settled in Claremont in the early 1900s worked in the citrus fields and packinghouses. From the very beginning, the Claremont barrios established places of worship and baseball teams. (Courtesy of Gilbert Guevara.)

MEXICAN AMERICAN BASEBALL IN THE POMONA VALLEY

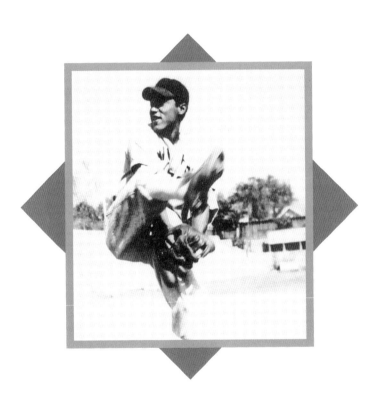

Richard A. Santillán with Mark A. Ocegueda, Alfonso Ledesma,
Sandra L. Uribe, and Alejo L. Vásquez
Foreword by Vicki L. Ruiz

Copyright © 2014 by Richard A. Santillán
ISBN 978-1-4671-3228-2

Published by Arcadia Publishing
Charleston, South Carolina

Printed in the United States of America

Library of Congress Control Number: 2014934517

For all general information, please contact Arcadia Publishing:
Telephone 843-853-2070
Fax 843-853-0044
E-mail sales@arcadiapublishing.com
For customer service and orders:
Toll-Free 1 888-313-2665

Visit us on the Internet at www.arcadiapublishing.com

To my wife, Teresa, and all the ballplayers in our family, Anthony, John, Alec, Román, Rhiannon, George, Joe, Carlitos, Nico, Christina, and a special tribute to Steve Oviedo

—Richard

For Karina, Daniel, and Sarah—Dream big and don't stop until you get there.

—Mark

Para mis padres, Emerita y Ignacio, and my husband Daniel—Thank you for your support.

—Sandra

To my loving wife, Lupe, who through her years of marriage can identify a baseball tramp

—Alfonso

To my wife, Carmen, and our four children, Juan, Steve, Anthony, and Judi

—Alejo

CONTENTS

Acknowledgments		6
Foreword		7
Introduction		8
1.	Azusa, Claremont, La Verne, and Pomona	9
2.	Chino, Cucamonga, Ontario, and Upland	27
3.	Military Baseball	45
4.	Women in Softball and Baseball	75
5.	The Golden State	91
6.	Coast to Coast	109
7.	Field of Dreams	121
Bibliography		126
About the Organization		127

ACKNOWLEDGMENTS

The foundation of this project to publicize the rich history of Mexican American baseball and softball in the Pomona Valley is due to the remarkable work of the Latino Baseball History Project at California State University, San Bernardino (CSUSB). Others who supported this effort include the following individuals and staff at the CSUSB's John M. Pfau Library: Dean Cesar Caballero and Sue Caballero, Jill Vassilakos-Long (head of archives and special collections), Iwona Contreras, Ericka Saucedo, Amina Romero, Carrie Lowe, Manny Veron, Brandy Montoya, Hayley Parke, John Baumann, and Stacy Magtedanz.

The authors are indebted to the players and their families who provided treasures of photographs and extraordinary oral histories. These dedicated individuals and groups include the following: José Alamillo, Estella Elías Acosta, Patricia Encinas García, Dorothy Romero, Jack Brown, Ralph and Ben Santolucito, Jim Bryant, Manuel Villegas, Rod Trasher, Tom Bonillas, Esteban Montéz, Carnera (Chayo) Rodríguez, Arcadio Acuna, Ray Amparan, Delfino López Anguiano, Fortino Mendoza, John Viveros, Chilo Martines, Pete Torres, José (Chevo) Hernández, Alfonso Gallardo, Richard Zaccato, Enrique and Hilaria Vásquez, Manuel Amparan, Maury and Tommie Encinas, Jim McLemore, Mel McGavock, Ralph Acuna, Ralph Bencomo, Tony Colunga, Frank Enciso, Sal Gallardo, Andy García, Ray Guerrero, Ángel Hernández, Eddie Jiménez, Andrew Ledesma, Rudy Leos, Tito Mendoza, Tony Muñoz, Perfecto Parilla, Albert Ramírez, Teofilo Rivera, Jim (Chayo) Rodríguez, Chino Sepúlveda, Albert Tello, Joe and Martín Valadez, Agustín Vásquez, Fernando Vásquez, Sonny Vásquez, Juan Vásquez, Ray Villa, Lebro Zandrino, Richard García, Stella Guevara, Gilbert Guevara, Tony Cervantes, Paul Gómez, Al Padilla, Charlie Sierra, Richard and Gabriel Peña, Rudy Félix, Ignacio Félix, Joe Romero, José Hermosillo, Chuck and Chico Briones, Gilberto Pérez, Enrique M. López, Phyllis Pérez, Theresa McDowell, Marcelino Saucedo, Lolo Hernández, Teresa Santillán, Rudy Gómez, Al De La Rosa, Al Padilla, Bob Lagunas, Ramona Cervantes, Richard Arroyo, Vicki Norton, Darcy Quinlan Meyer, Linda Castro Spencer, Eddie Navarro, Rey León, Grace Guajardo Charles, John Y. Dickinson III, Sonny Benavidez, Isabel Ramírez, Lano Oropeza, Michael Cervantes, Cecilia Estrada, Elvera Díaz Jiménez, David Trujillo, Mónica Ortez, Ray Torres, Joe Talaugon, Richard Sánchez, Joe Escareño Jr., Jim Campos, Martín and Ángel Cortinas, Charlotte Montijo Sauter, Ron Baca, Oscar Chacon, Sergio Hernández, Kelvin Paz, Bea Armenta Dever, Rosemarie Olmos Esquivel, Jaime Castel De Oro, Remi Álvarez, Gabby Mendoza, Ray Rodríguez, Olivia Cortéz, Victor and Mary Ruiz, Anita Valadez-García, Lalo Olagués, Priscilla Poppinga, Ray Sevilla, Eddie García Jr., Bobby Duran, Buddy Muñoz, Vince Martínez, Abe Contreras, Henry and Cecilia Toledo, Cuno and Karla Barragán, Mary Camacho, Ralph Castañeda Jr., Ernie Cervantes, Ray and Hillie Delgadillo, Sally Hernández, John Hernández, Bob Lagunas, Cindy Swartwood, Rod Martínez, Richard Méndez, Ramona Reyes, Ray Salazar, Lucy and Hank Pedregón, Carlos Uribe, Richard Cortéz, Joffee García Jr., Bill Miranda, Buddy Dueñas, Irene Negrete, the Studio for Southern California History, Southeast Chicago Project, Señoras of Yesteryear, Ethnic and Women's Studies Department, the Cesar Chávez Center at Cal Poly Pomona, and all of the loyal fans and business merchants of Cucamonga.

A special thanks to Alfonso Villanueva Jr., whose tireless work help make chapters one and two possible. We recognize again the professional work of our in-house editor, Elisa Grajeda-Urmston, and offer special appreciation to our technical consultant Mark Ocegueda. Last but not least, our heartfelt appreciation to Arcadia Publishing and our remarkable and patient editor, Jared Nelson.

FOREWORD

An ace pitcher for Jimmy John Lumber, a young Matt García had no inkling of the rich mound of history on which he stood. Years later, as a doctoral student, García began to uncover the legacies of family members and their neighbors in the making of the Greater Pomona Valley. His 2001 book *World of Its Own: Race, Labor, and Citrus in the Making of Greater Los Angeles, 1900–1970* broke new ground by emphasizing the experiences of Mexican Americans not as faceless workers or members of isolated communities but as individuals with hopes and dreams, who in the course of their day interacted with European Americans and African Americans. Focusing primarily on the decades between 1920 and 1960, Matt García captured moments of tension between Mexican American men and braceros in Claremont's Arbol Verde barrio to moments of collaboration between African American and Latino musicians who played at the popular integrated dance hall, the aptly named Rainbow Gardens. Conveying the texture of human emotion, he offers a sense of people in motion and of the communities in which they lived. The pride Professor García takes in his local roots resonates in the memories and photographs beautifully assembled in the pages that follow.

Scholars have taken notice of the Latino love affair with baseball, and I refer readers to two engaging works on the topic: Adrian Burgos's *Playing American's Game: Baseball, Latinos, and the Color Line*, and Samuel Regalado's *Latin Major Leaguers and Their Special Hunger*. Moreover, José Alamillo's *Making Lemonade out of Lemons: Mexican American Labor and Leisure in a California Town, 1880–1960* underscores the importance of baseball not only to community rhythms and cultural identity but also to political empowerment. With a wider public in mind, the Arcadia Publishing book series provides stunning visual testimonies that, taken together, reveal baseball's impact on the daily lives of Mexican Americans in Southern California. For youth, Little League instilled leadership and team building, and for adult players, many found jobs, met their future spouses, and at times organized for civil rights. For almost a century in Southern California, Mexican American men and women have rounded the bases, cheered from the stands, and made vibrant, enduring communities that span generations.

—Vicki L. Ruiz
Distinguished Professor of History and Chicano Latino Studies
University of California Irvine

INTRODUCTION

The Greater Pomona Valley is located between the San Gabriel Valley and the Cucamonga Valley, straddling the border between Los Angeles County and San Bernardino County. In 1893, the California Assembly voted to form a new county, San Antonio County, with Pomona as its seat. However, Los Angeles political and economic interests defeated the proposal. Today, the Greater Pomona Valley is divided between western San Bernardino County and eastern Los Angeles County and surrounding communities of interest. Since the early 1900s, Mexican American communities have sprung up mainly due to the push and pull of economic factors, especially in the cities of Azusa, La Verne, Claremont, Pomona, Chino, Cucamonga, Upland, and Ontario.

Mexican Americans worked largely in the packinghouses, railroads, and citrus fields. Like their counterparts throughout California and the nation, they quickly established a complexly detailed set of organizations that promoted civil, cultural, and political rights. Moreover, they created sports networks at the local, state, and national levels. Nearly every community, small or large, had baseball teams representing it. While the rise of baseball as a spectator sport in the Mexican community simply reflected the rise of mass spectator sports in the country, Mexican American baseball, without shame, promoted the sport to reaffirm Mexican heritage and to advance a political agenda.

Moreover, teams traveled to nearby communities, crisscrossed county lines, traversed within their respective state borders and across state lines, and ventured into Mexico. These baseball trips established permanent networks that eventually merged into an interrelated maze of families, labor associations, and political groups. Both labor and sports were exceptions to the general rule that segregated Mexicans within the physical confines of where they lived. With sports, Mexicans were able to travel near and far to make contact with countless communities and talk not only about baseball but also their political strategies.

It must have been an incredible sight to see dozens of cars and trucks carrying players and their fans to out-of-town games. As they approached their destinations, the cars honked their horns signaling their arrival. With sports, interlinked communities built a stronger sense of pride and cultural unity and a common destiny.

AZUSA, CLAREMONT, LA VERNE, AND POMONA

The Mexican American "foothill communities" of Azusa, Claremont, La Verne, and Pomona played a vital role in what was once considered one of the richest agricultural areas in the United States. Carey McWilliams, the noted journalist and historian, wrote that this region was neither rural nor urban. Mexican Americans were systematically excluded and segregated by the various mainstream social institutions up until the later part of the 20th century.

Baseball and softball leagues served a pivotal role as athletic, entertainment, and social outlets in the historical evolution of these *colonias*. Consequently, throughout the decades, Mexican American baseball leagues and organizations evoked the formation of an important arena where Mexican Americans helped influence the larger society and contributed as a political vehicle that sought to expand the space of their lives.

Mexican Americans in the Pomona Valley, especially the foothill communities, were not socially immune from the terrible experiences that impacted their compatriots in the larger urban centers of this country, including educational segregation, police brutality, lack of adequate housing, low-paying jobs, and social segregation in public places including theaters, restaurants, and public pools. The baseball diamond was where the community came to cheer its favorite team and boo the opposing players, but it was also an arena where politics were discussed, strategies formulated, petitions and flyers circulated, money raised for campaigns and lawsuits, voters registered, citizenship information distributed, union dues collected, war bonds sold, and economic boycotts of specific downtown businesses that refused to serve Mexican Americans announced.

Thus, baseball and softball were intertwined within the larger agenda for political, educational, and civil rights. At all levels of ball, including youth, collegiate, adult, women, professional, and military, baseball had a political side. The elders made sure of it. Baseball in this region dates back to the early 1900s, and many of these teams and their families would later become the champions not only of baseball but also within the bigger diamond of American society.

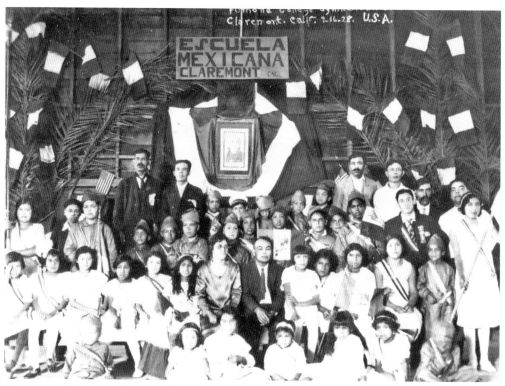

The original families who settled Claremont worked at the citrus packinghouses, the Claremont Colleges, and, if they had talent, at the historic Padua Hills Theatre. Every Mexican Independence Day from the 1920s through the late 1930s, the elders organized a youth march from the East Barrio to Renwick Gymnasium at Pomona College, where they taught young people their Mexican history. A picture of Guadalupe Hidalgo, the priest who led the independence movement, hangs on the wall. (Courtesy of Alfonso Villanueva Jr.)

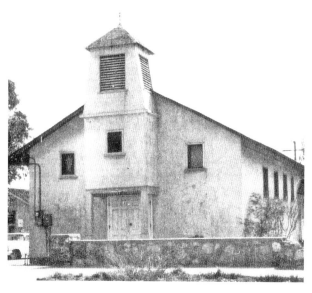

Mexican Americans were not welcomed to many Catholic churches throughout the country. This was their sad experience at St. Joseph's in Pomona and St. George in Ontario. Sacred Heart of Jesus Chapel was built by the residents of both the East Barrio and Árbol Verde. It was built in 1938 after years of fundraising *jamaicas*. The first mass was held at the Enriguez home on Blanchard Place in Árbol Verde in 1912. Sacred Heart was razed in 1968 to widen Claremont Boulevard. (Courtesy of Alfonso Villanueva Jr.)

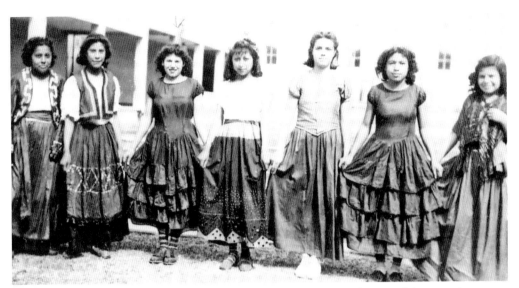

Dancing was an important form of cultural reaffirmation. Nearly every Mexican American community had a *folklórico* group of young women. Their teachers were often elderly women who had learned the regional dances from their elders in Mexico. It was not unusual to see these dance groups perform at local theaters, church functions, and during and after baseball games. From left to right are Angelina Elías, unidentified, Sarah Gallegos, Jennie Alanis, Carmen López, ? Terrones, and Virginia Miranda. (Courtesy of Lalo Olugués.)

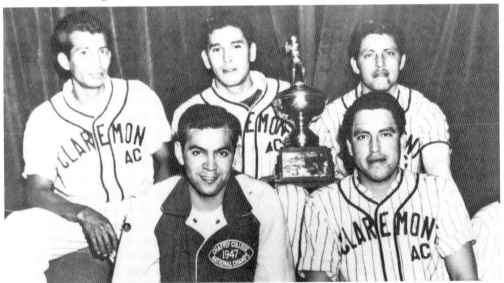

This 1951 photograph depicts the star players of the Claremont Athletic Club that won the coveted Bradley Trophy as the best fast-pitch team in the Pomona Valley. From left to right are (first row) David Arnulfo Villanueva, and Tony Gómez; (second row) Ray "Poke" Guerrero, George Encinas, and Paul Gómez. "Poke" earned his nickname because he poked the ball hard and far. Paul Gómez was a successful police officer for the La Verne and Claremont departments. He passed away in 2013. (Courtesy of Rudy Gómez.)

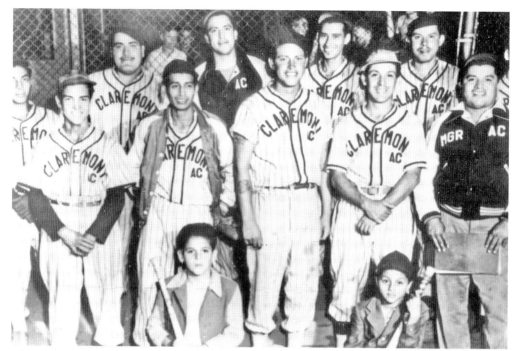

This photograph shows another Claremont Athletic Club team. From left to right are (first row) batboys Rubén Gómez and Frank Molina Jr.; (second row) Freddie Gómez, Ray "Poke" Guerrero, Paul Gómez, Rigo Gómez, and manager Frank Molina; (third row) Joe Aguilera, Ramón Sevilla, Tony Gómez, Joe Félix, Román Salazar, and unidentified. Ramón and Mary Sevilla raised six children: Margaret, Ray, David, Danny, Richard, and Delia. Ramón was also a former professional wrestler. (Courtesy of Claremont Heritage.)

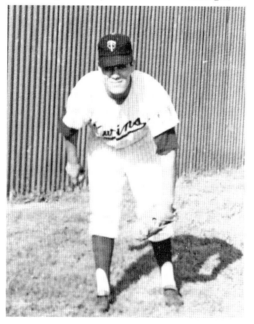

Ray Sevilla was born in 1941 in Pomona and raised in Claremont. He played softball since there was no Little League. He played hardball in the seventh grade and lettered three years at Claremont High School, where he was named All-League his last two years. He also played football for four years, leading his team to two California Interscholastic Federation championships. He played two years at San Bernardino Valley College and was signed by the Minnesota Twins in 1962, playing in their minor-league system. (Courtesy of Ray Sevilla.)

Tony Gómez (right) was born in 1925 to Frank and Leah Gómez in Claremont. Tony dropped out of Chaffee High School in Ontario to pick oranges for several citrus companies to help his family. During World War II, he served with the 112th Cavalry regimental combat team as a machine gun squad leader. He and Dolores Cuevas raised six children. He worked for Kaiser Steel in Fontana, from which he retired after 29 years. He pitched for the Kaiser softball team. Standing next to him is Louie Guevara. (Courtesy of Rudy Gómez.)

Nellie Gutiérrez Villanueva was born in 1932 in the Árbol barrio of Claremont. She posed for this photograph in 1956 while she was performing with the famous group Mexican Players and Dancers at the historical Padua Hills Theatre in Claremont. She met her future husband, Alfonso Villanueva, at a baseball game in 1947 when he was playing for the Question Marks. Both Nellie and Alfonso attended segregated schools in Claremont and Ontario, respectively. (Courtesy of Alfonso Villanueva Jr.)

Alfonso Villanueva Sr. was born in 1929 in the Sunkist barrio of Ontario, California. His mother, Luz, was one of the founding members of the Guadalupanas and his father, Emilio, was involved with La Progresistas Sociedad. Alfonso is featured in his Ontario Question Marks uniform in 1947. He was an outstanding softball hurler who could throw fast. Besides playing, Alfonso managed several teams from the 1960s through the early 1980s, winning several league and tournament championships in the Pomona Valley and Southern California. (Courtesy of Alfonso Villanueva Jr.)

Alfonso and Nellie Villanueva had five children, Yolanda, Alfonso Jr., Emilia, Rolando, and Steven. Alfonso Sr. (not shown) played for the Question Marks. Alfonso Jr. played with Montclair Pop Warner and Upland High School teams. He also played Upland and Claremont Little League and Pony League. Steven excelled in football and basketball. He quarterbacked the Claremont barrio football team against an undefeated Pomona "12th Street" team at El Barrio Park before 1,500 people from Pomona, Claremont, and surrounding communities. Rolando excelled in basketball and softball. (Courtesy of Alfonso Villanueva Jr.)

Seen here are three players for the Claremont Athletic Club. Ignacio Félix (center) was born in Claremont and still lives there today. He played baseball before going into the service during World War II, where he also played service ball. His brother, Joe Félix (left), was born in Pomona and grew up in Claremont. He served in the Air Force and later worked for Lockheed. Their teammate is Pat Martínez (right). Martínez worked for the highway patrol and is now a deacon. (Courtesy of Rudy Félix.)

Rudy Félix, the son of Ignacio Félix, played two years of Little League at shortstop and two years of Pony League in the outfield in Claremont during the 1960s. His Pony League team was the Yankees. Rudy also played 20 years on softball teams. He played many years for a team called the Sandbaggers. He has played on coed team including for the Costco store. Rudy has pitched, caught, and played outfield. He umpired three years for the Claremont Little League. He works with the US Postal Service. (Courtesy of Rudy Félix.)

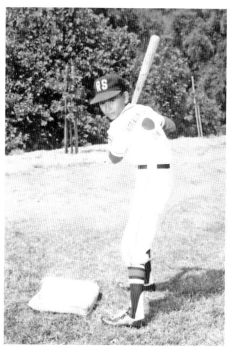

Jerry Félix, brother of Rudy, played one year of Claremont Little League with the Red Sox in 1969. His position was outfielder. He went on to play with the Giants Colt League team in Claremont. Jerry also played 30 years of Unlimited Arc men's softball as a pitcher. He managed the little-league team of Rudy's son, Gabriel, in 1986. Jerry attended elementary, middle, and high school in Claremont. He currently works for the US Postal Service. (Courtesy of Jerry Félix.)

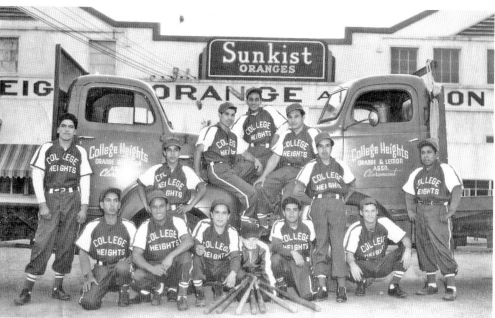

There were several packinghouses in the Pomona Valley, especially in Claremont. Most worksites had baseball and softball teams, often dominated by Mexican American players. This is the Sunkist Oranges team. From left to right are (kneeling) Pete Baltierra, Manuel Gonzáles, Vincent Álvarez, and three unidentified; (standing) Salvador Sevilla, Gilbert Guevara, Manuel Guevera, and Lupe Carmona; (sitting on the truck) Elías Guevara, unidentified, and Peter Belmúdez. (Courtesy of Gilbert Guevara.)

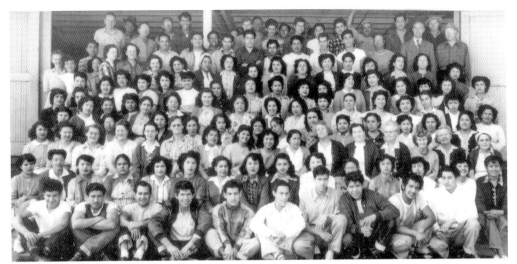

The employees of the Claremont Heights Orange and Lemon Association gather for a group photograph in 1951. The packinghouse was located on First Street just west of Indian Hill Boulevard in Claremont. Some of these men played for the Claremont Athletic Club baseball team. A few of the individuals in this picture are Katy Aguayo, Delia Martínez Félix, Ernie, Ignacio, and Joe Félix, Katie García, Freddie, Paul, and Tony Gomez, Trini Hernández, Alice Mendoza, and Helen Ruiz. Today, the packinghouse has been converted into shops and restaurants. (Courtesy of Rudy Félix.)

Joe Hermosillo was born and raised in Claremont and had an outstanding baseball and softball career. He and his brother Louie played on several youth teams, including Colt League and in high school. He later played in the semiprofessional Sunset League. This 1958 team, known as Nano's, is, from left to right, (first row) Richard Sevilla, John Domínguez, and José Abundiz; (second row) David Sevilla, Nano Contreras, Danny Sevilla, Joe Hermosillo, Robert Sevilla, Raymond Cándelas, Tony Contreras, Steve ?, and Albert Gutiérrez. (Courtesy of Joe Hermosillo.)

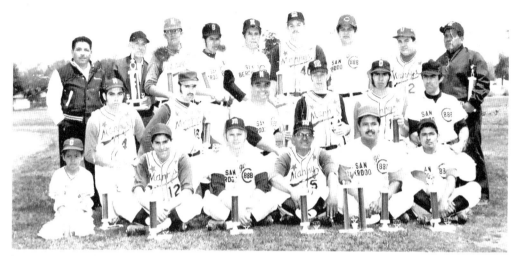

Joe Romero was born in Las Cruces, New Mexico, and raised in Cucamonga. He played for the Nine Aces in 1952 with Richard Martínez, Al and Louis Vásquez, Tony Muñoz, and Richard Zacarro. Joe played for the Claremont Barons in 1963 and played and managed the Upland Angels. The Angels won the 1975 Sunset League championship, beating the Cucamonga Mets. Joe (third row, second from right) managed and played for Manny's in San Bernardino. Other players included Joe Hermosillo, Rudy Mendoza, Manuel Martínez, and Pete Reyes. (Courtesy of Joe Romero.)

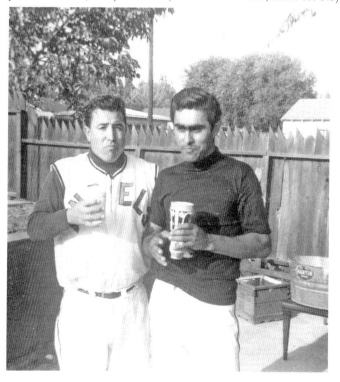

Joe Romero (left) and Joe Hermosillo (right) were very typical of players of their generation who played ball for several teams and communities. Although they mainly played ball in the Ontario and Upland areas, they played for and against teams in Claremont and San Bernardino. Moreover, it was not unusual to find crosstown marriages between Ontario and Upland with Claremont and Pomona. Many players in the Pomona Valley played in Mexico, having the advantage of speaking both Spanish and English. (Courtesy of Joe Romero.)

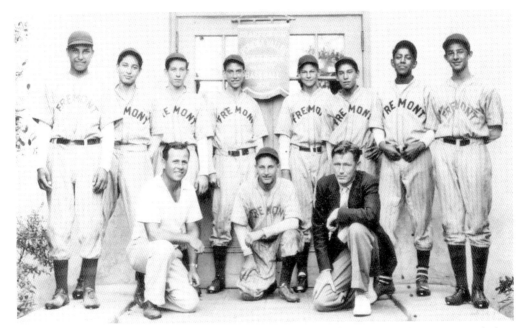

The 1936 Freemont Junior High School team included a handful of Mexican Americans, including Mike Miranda (second row, far left), George Encinas, and Eddie García. Mike Miranda would later become the mayor of Irwindale. George Encinas's grandson, Chad Cordero, later played for the Los Angeles Angels of Anaheim baseball organization. (Courtesy of Eddie García Jr.)

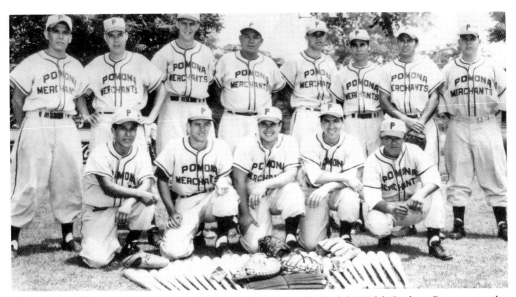

The Pomona Merchants were a semipro team that played at Ralph Welsh Park in Pomona in the San Bernardino Valley League. From left to right are (kneeling) Gil Guevara, Landon Moore, Joey Fuentez, Dan Dioses, and Julio Rodríguez; (standing) Maury Encinas, George Estrella, Dick McAnulty (manager), Sisto Armenta, Vic López, Tommie Encinas, Bobby Duran, and Harry Estrella. (Courtesy of the Tommie Encinas family.)

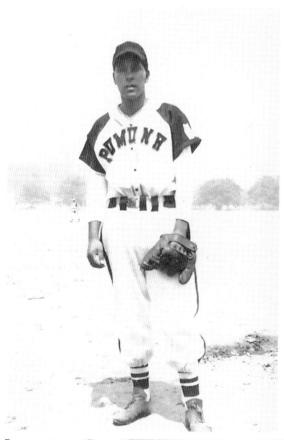

Bobby Duran was born in 1927 to Melesio and Ramona Duran. There were six brothers, Alex, Luís, Mel Jr., Henry, Bobby, and Alfred. All of the Duran brothers were outstanding players in baseball, basketball, and football. Bobby's five brothers served in World War II or Korea. Their father worked at the Kellogg Ranch, now Cal Poly Pomona, on the farm and with the Arabian horse show. Bobby would help his father at the ranch. Their father later worked for the City of Pomona. (Courtesy of Bobby Duran.)

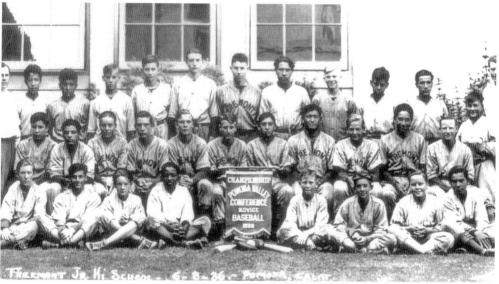

This Fremont Junior High School team included several Mexican American players, including Vincent Álvarez, Soupy García, Tommie Encinas, Jess Trujillo, Robert Barela, Jimmy Turner Sr., Orlando Barela, Simón Baltierra, and Jess Ontiveros. (Courtesy of the Tommie Encinas family.)

Tommie Encinas was raised in Pomona, California, and is seen here in his Waco (Texas) Pirates uniform. Tommie was signed by the Boston Braves in 1946 and began his professional career in Leavenworth, Kansas, in the Class C Western Association. In 1947, Tommie was traded to the Pittsburgh Pirates organization, where he played for the Uniontown Coal Barons in Pennsylvania and the Selma Cloverleafs in Alabama. Tommie's two brothers, George and Maury, were also star players in the Pomona Valley. (Courtesy of the Tommie Encinas family.)

Buddy Muñoz was born in Miami, Arizona, and later moved to Pomona, California, where he was the MVP of his baseball team in both his junior and senior years at Pomona High School. He pitched for Mount San Antonio College in 1954 and 1955. He graduated from the University of Southern California with a master's of business administration. He retired from the Los Angeles County Probation Department in 1992. His daughter, Kelli, played softball at Cal State San Bernardino in 1994–1995. She has been a winning softball coach for 20 years. (Courtesy of Buddy Muñoz.)

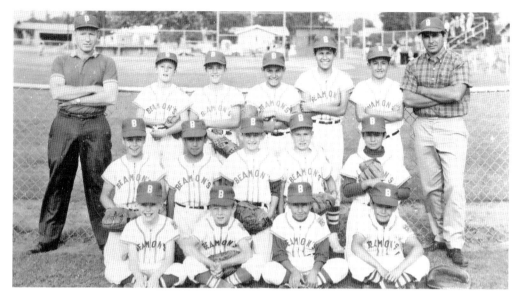

This 1963 Pomona American Little League team was coached by Bobby Duran (right). His three sons are on the team: Rod (first row, second from right), Bobby Jr. (third row, third from right), and Rudy (third row, fourth from right). Bobby's three sons were outstanding athletes in football, basketball, and baseball. They played Little League, Pony League, and high school. Bobby Jr. played at Garey High School when they were the California Interscholastic Federations (CIF) champions. He also had a tryout with the Anaheim Angels. (Courtesy of Bobby Duran.)

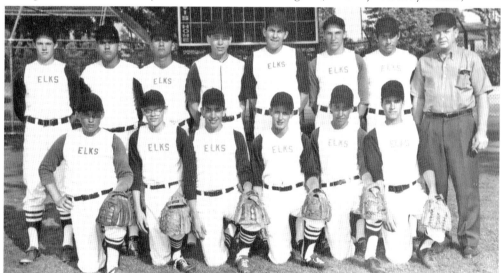

Rudy Duran (second row, second from right) and his brother Bobby Jr. (second row, fourth from right) played for the Pomona Elks. During his illustrious career, Bobby Sr. played against the best teams and players. He played against the Encinas brothers from Pomona, the Uribe brothers from Corona, the Vásquez brothers from Cucamonga, and the Guevara brothers from Pomona. Their brother Rod (not pictured) was an outstanding hitter and fielder and had a great future but was seriously hurt when a coach pushed him too hard. (Courtesy of Bobby Duran.)

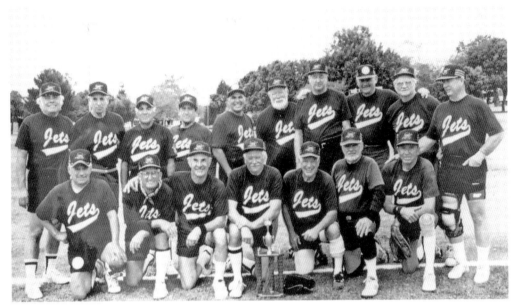

Bobby Duran started a youth league in Pomona and coached a team called the Jets until the age of 55. He later formed a senior team also called the Jets. He played with several senior teams including one in Chino until he retired from the game in his 80s. In his youth, Bobby was known as "the Jet" and "Relámpago"—Spanish for "lightning"—because he was so fast. He played ball in Mexicali with Maury Encinas for the Águilas, a Pittsburgh Pirates minor-league team. (Courtesy of Bobby Duran.)

Ralph Valadez played for the Ontario American Legion, was an All-League shortstop in his junior and senior years in high school during the early 1970s, and was selected to the California all-star team. He played at Chaffey Community College, helping the team win its league. He played at the University of La Verne as an outfielder and designated hitter. Ralph played two years of semipro ball in Halstead and Dodge City, Kansas, and was offered a contract by Minnesota Twins scout Jesse Flores. (Courtesy of Anita Valadez-García.)

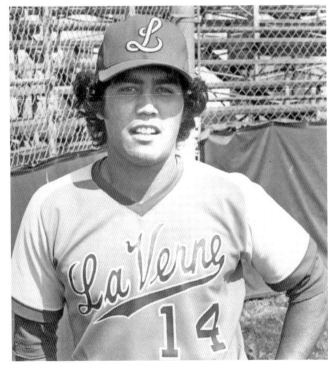

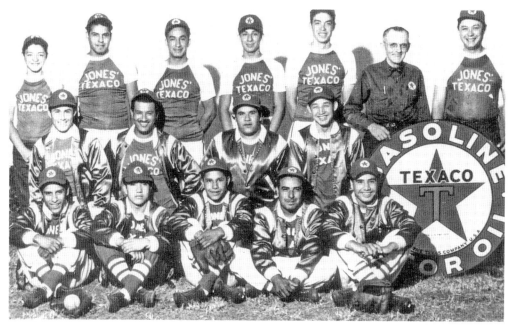

The Mexican American community of La Verne has produced outstanding teams and extraordinary players since the 1930s. This is the Jones Texaco team from La Verne in the late 1940s. From left to right are (first row) Johnny Carmona, Steve Mora, Manuel García, Philip Banales, and David Rodríguez; (second row) Joe Ramírez, Buddy Soto, George Soto, and Pete Martínez; (third row) Jess Martínez, Benny Castellano, Pete Aguilera, Art Escoto, Nacho Martínez, Mr. Jones (team sponsor), and Fred Martínez (manager). (Courtesy of Vince Martínez.)

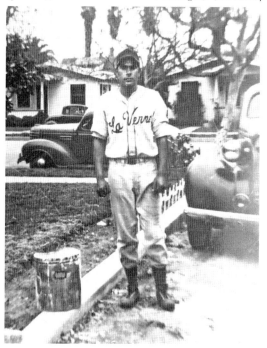

Although Bobby Duran was from Pomona, he was forced to play in La Verne in 1945 because the Pomona American Legion parents did not want Mexican kids playing with their kids. Bobby played for the La Verne Merchants. His manager was Charlie "La Tortuga" (the turtle) Rodríguez. Several teams scouted Bobby, including the Braves, Pirates, and Dodgers. Jackie Robinson spoke to Bobby about playing for the Dodgers' minor-league system, but Bobby turned the offer down because the salary was too low to support a new family. (Courtesy of Bobby Duran.)

Manuel R. Romo purchased several lots of property behind Palomares School in La Verne where teams played baseball. Pictured on the left is Manuel's second cousin Guadalupe Carmona, who worked hauling fruit but loved playing ball. The aunts who now own the lots would sell burritos during the games. Due to the widening of the road, many homes were torn down to build Arrow Highway. Today, a sign hangs above one of the uncles' driveway gate that reads "Romo Land Est. 1900." (Courtesy of Dennis Duke Romo.)

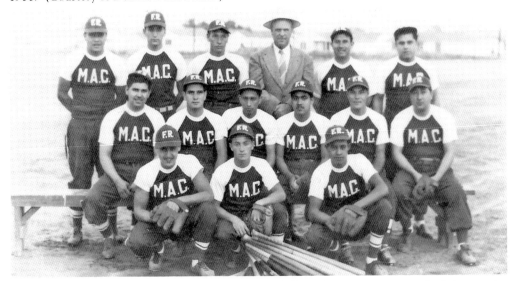

The 1947 Mexican American Athletic Club (MAC) from Azusa was comprised of players who had served in World War II. From left to right are (first row) Tony Arias, Oscar Aguirre, and Frank Irigoyen; (second row) Lino Arriaga, Bobby Álvarez, Henry Toledo, unidentified, Jesse Bracamontes, and Herman Domínguez; (third row) Salvador Luévanos, Tony Ortiz, Art ?, unidentified, Tony García, and Pete Gonzáles. Luévanos was scouted by the New York Giants. Toledo later served in the Korean War. The MAC team played against local teams including Ortuño's Market. (Courtesy of Abe Contreras.)

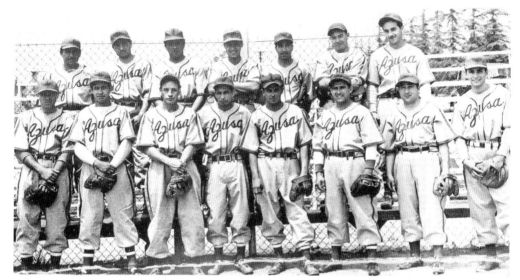

Azusa has a rich history of Mexican Americans in sports. Mexican Americans were outstanding stars in youth leagues and in high school, lettering in baseball, basketball, football, tennis, and wrestling. Moreover, the young men of Azusa defended their country during World War II and Korea. This 1948 Azusa team was comprised of several extraordinary players, including Cruz Guerrero, Mike Miranda, Manuel Toledo, Hank Toledo, and Mickey Silva. Miranda and Silva were from nearby Irwindale. Manuel Toledo was the manager. (Courtesy of Henry Toledo.)

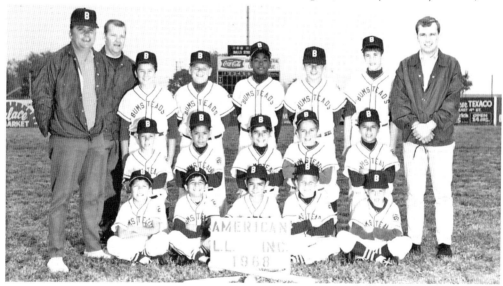

The 1968 Ontario Little League championship team was sponsored by Bumstead's Sporting Goods store. There are several Mexican Americans on this team whose families have lived in Ontario for generations, including the four López cousins: Ron, Victor, Albert, and Enrique. Ontario American and Central Little Leagues played at Bud Eldrige Park, built in 1961 on what was formerly El Barrio del Chile, where chiles, sweet potatoes, and green beans were grown. Ontario teams played against Pomona, Claremont, Azusa, and La Verne. (Courtesy of Enrique López.)

Chino, Cucamonga, Ontario, and Upland

As early as the 1930s, and in the midst of the Great Depression, people could forget their long, hard, tedious workweek by gathering on Sunday afternoons at the baseball field watching their favorite Mexican American players and teams in Chino, Cucamonga, Ontario, and Upland. In Cucamonga, the ballpark was located at the southwest corner of Archibald Avenue and Eighth Street, the home field of the Cucamonga Merchants.

Many of the ballparks in the Mexican American communities were "band-box" size, which made for a more fan-friendly atmosphere, and consequently the noise level was more pronounced—so much so that it seemed like the more boisterous the crowd, the more dust rose over the ball field. The games were festive events, with music, food, and of course exciting baseball. Parents could make it a nice afternoon by walking their young children to the game, buying them treats, and giving them the remarkable experience of watching players and teams with immense talent and skill.

Young men who loved playing baseball had many choices, including organized youth baseball and softball, school baseball, Junior Merchants, Merchants, Catholic Youth Organization, street baseball, and semiprofessional. A few lucky ones signed college and professional contracts, while a few special ones played ball in the military. Young women also played ball on school and community teams. They, too, proudly entered the competitive arena of ball to display their wonderful skills and love for the game.

World War II saw much of the sports scene in Mexican American communities in the Greater Pomona Valley disappear as Mexican American men and women served in the armed forces and defense plants. As noted, a few Mexican Americans did play military baseball and still fought on the battlefield. The postwar period was bittersweet as ballplayers from the 1920s through the 1940s retired or died but were replaced by a new generation of extraordinary players and teams who would dominate Mexican American baseball and softball from the late 1940s into the early 1960s. Armed with the GI Bill and a new wave of Mexican American political activism, Mexican Americans would demand social equality, especially the further inclusion of Mexican Americans in school and city teams and leagues.

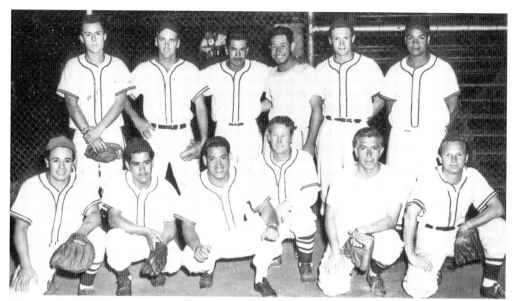

The 1954 Douglas Aircraft Company softball team included at least four Mexican Americans. On the second row at far right is Al Vásquez. The first three players in the first row from left to right are Ralph Martínez, Tito Mendoza, and Felipe Lujan. Al Vásquez played on various baseball and softball teams and was well known for his brilliant brand of baseball throughout Southern California. Tito Mendoza was a decorated hero of World War II with the 101st "Screaming Eagles." (Courtesy of Al Vásquez.)

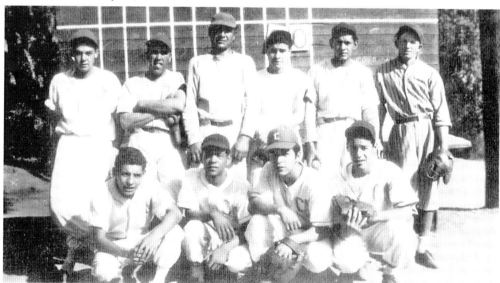

The Cucamonga Merchants had only a small section of bleachers on their field, so their fans had to view the games by sitting either in or on their cars. Exciting game moments were acknowledged by honking vehicle horns. This 1950 team included, from left to right, (first row) Tony Lujan, Ray Huerta, Tito Mendoza, and Lou Vásquez; (second row) Lucas Villarreal, Ray Amparan, Ángel Hernández, Rudy Leos, Jesús Porras, and Ray García. (Courtesy of Al Vásquez.)

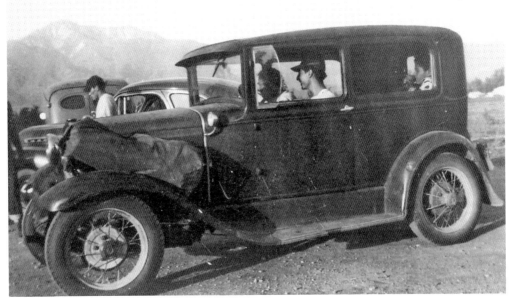

Cars were essential for work, medical visits, shopping, traveling to see friends and relatives, and playing games far away from home. Players would joke among themselves about the Junkee Stadium Limo Service before heading out to compete against teams as far as Los Angeles, Orange County, San Diego, and the Imperial Valley. Home teams often took up donations to help subsidize visiting teams with gas money. The 10,000-foot Cucamonga Peak can be seen in the background. (Courtesy of Al Vásquez.)

Several Mexican American communities in the Greater Pomona Valley established sophisticated baseball leagues with home and away schedules including Mexico, fundraising events, media relations, minor-league and youth teams, outstanding managers and coaches, spring training, and umpires. Former Cucamonga Merchants player Chevo Hernández was often referred to as the classiest-dressed umpire in the Valley League. His motto was " I call them *como las veo* (as I see them)." (Courtesy of Al Vásquez.)

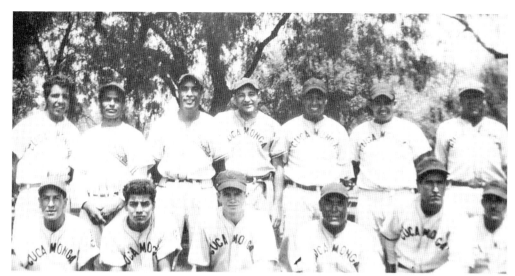

The 1954 Cucamonga Merchants was a powerhouse team with several outstanding players. From left to right are (first row) Teofilo Rivera, unidentified, manager Alfonso Ledesma, Delfino Anguiano, Sal Gallardo, and Andy García; (second row) Charlie Flores, Perfecto Parrilla, Al Gallardo, Frank Enciso, Al Vásquez, Albert Ramírez, and Ray Amparan. In 1956, the Merchants became history, followed by the dissolution of the Valley League, giving rise to a much stronger and more centrally located Sunset League. (Courtesy of Al Vásquez.)

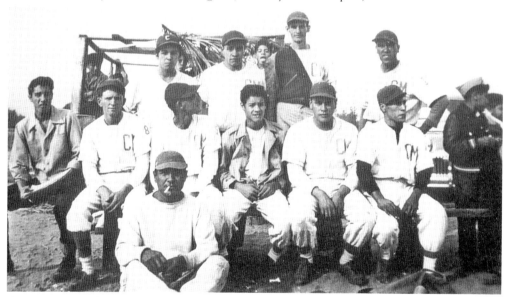

A promising youth movement started in the early 1950s, only to be partly stalled due to military service commitments during the Korean War. This 1949 Cucamonga Merchants team included, from left to right (front row) Ángel Hernández; (second row) Joe Pérez, Ray García, Joe Valadez, Lou Vásquez, Manuel Amparan, and Sal Gallardo; (third row) Tino Mendoza, Rudy Leos, Martín Valadez, and Ray Amparan. Ángel Hernández is the grandfather to Anthony Muñoz, the former Cincinnati Bengals player. (Courtesy of Al Vásquez.)

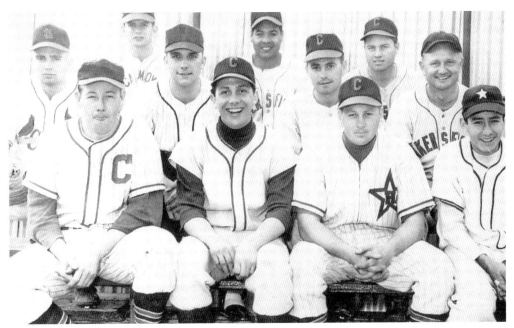

This is the last team that the Cucamonga Merchants sponsored in 1956. The first team was in 1945. Its founder, Esteban Montéz, solidified himself as the most prominent of the Cucamonga managers. The team's first field, located on Arrow Highway near Vineyard Avenue, first served as a Civil Conservation Corps (CCC) camp during the New Deal administration of Pres. Franklin Roosevelt. Players included Sonny Vásquez (first row, far right), manager Alfonso Ledesma (third row, far left) and Al Vásquez (third row, middle). (Courtesy of Al Vásquez.)

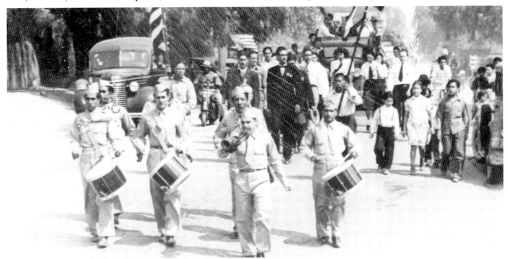

Pictured is the start of the September 16, 1944, Fiestas Patrias parade as it marches on Twenty-fourth Street into Turner Avenue (now Hermosa). Parade grand marshals (in dark suits) are Enrique Vásquez (left) and Joe Valadez (right). The drum and bugle corps is led by Álvaro Torres and includes locals Jesus Vásquez and Isaac Flores, with the remainder composed of Mexican National Laborers (Braceros) housed at the CCC camp on Arrow Highway. (Courtesy of Al Vásquez.)

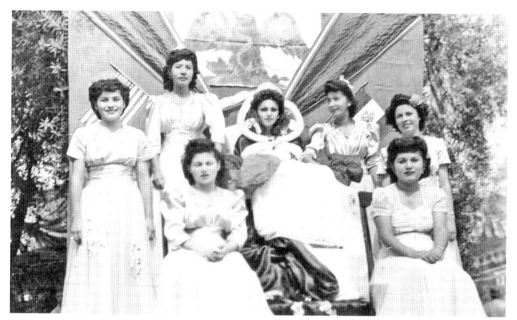

The 1944 Fiestas Patrias queen, Aurora Valadez, and her court highlighted Cucamonga's Mexican Independence Day celebration. Three or four months before the September 16th fiesta, festive events were held to allow the candidates vying for queen to sell tickets for their candidacy. The young lady selling the most tickets was named queen. Queen Aurora's court was composed of, from left to right, Rosa Caballero, Simona Vásquez, Felicitas Sánchez, and Mary Villareal. Seated in front are Becky Bustos (left) and Ermina Delgado (right). (Courtesy of Al Vásquez.)

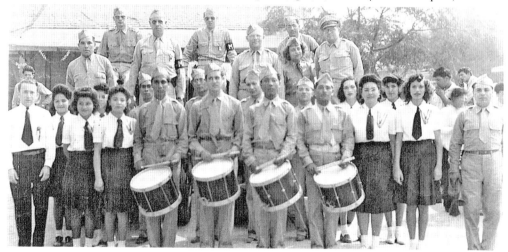

During World War II, Ontario Airport was an Army Air Corps base. Military personnel stationed there flew and maintained the P-38 Lighting fighter planes. Among the duties of the military police was to patrol the streets of Cucamonga, so they were invited to participate in the Mexican Independence Day celebration. They eagerly accepted. Cucamonga residents of the drum and bugle corps included leader Álvaro Torres (first row, far right), Jesús Vásquez (third row, second from left), and Isaac Flores (third row, fourth from left.) (Courtesy of Al Vásquez.)

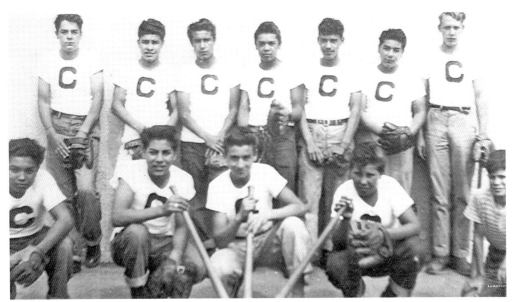

Softball, like baseball, was a big part of the day-to-day activities of youth in Cucamonga. Pictured here is the 1946 softball team from Cucamonga School, located on Archibald Avenue and Eighth Street. From left to right are (kneeling) Albert García, Macario Rodríguez, Ralph Acuña, Joe Bencomo, and Alfonso Ledesma; (standing) Lucas Villareal, Rudy Leos, Lorenzo Fierro, Kino Montoya, Ángel López, Rudy Mendoza, and Jack Roper. (Courtesy of Ray Rodríguez.)

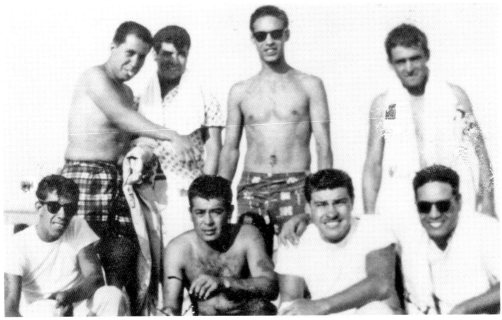

Like today's youth, Mexican Americans enjoyed spending a day at the beach to relax. This is a 1956 Cucamonga team in Long Beach, California. From left to right are (kneeling) Ralph Bencomo, Sammy Caballos, Rudy Leos, and Al Vásquez; (standing) Joe Bencomo, Art Moreno, Louie Vásquez, and Ralph Acuña. (Courtesy of Rudy Leos and Ray Rodríguez.)

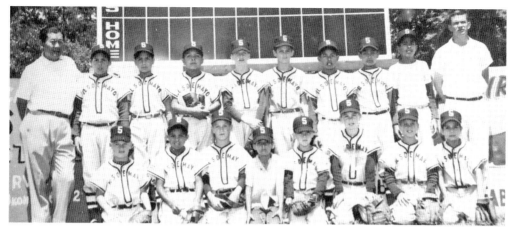

El Cinco de Mayo was one of the four original teams forming the Cucamonga District Little League in 1956. This 1958 team was sponsored by El Cinco De Mayo Wholesale Meats and Mexican Food Products. From left to right are (first row) Leon Manning, J.J. Ramos, Danny Solters, batboy Art Lujan, Truman Makabe, George Sebesta, Alan Sutton, and Phillip Lujan; (second row) coach Paul Makabe, Mike Leon, Ray Rodríguez, Tommy Ramos, John Moore, Dick Bitter, Gilberto Pérez, Agustín Vásquez, coach Jesse Pérez, and manager Alfonso Ledesma. (Courtesy of Gilberto Pérez.)

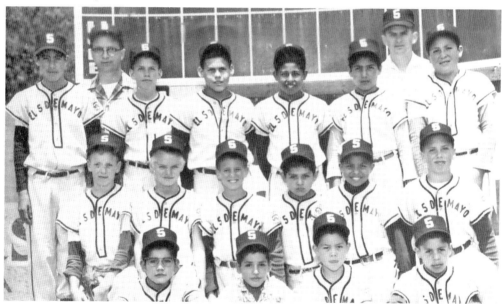

The 1959 Cucamonga District Little League El Cinco De Mayo team won the championship. Its winning percentage was nearly .800 over 10 years, and the team never finished lower than second place. From left to right are (first row) Phillip Lujan, batboy Artie Lujan, Truman Makabe, and Vidal Meza; (second row) Danny Solters, Leon Manning, Alan Sutton, Rudy Mendoza, J.J. Ramos, and John McGivney; (third row) Richard Ayala, coach Bob Sutton, John Morris, Mike Leon, Gilberto Pérez, Raymond Rodríguez, manager Alfonso Ledesma, and Henry López. (Courtesy of Alfonso Ledesma.)

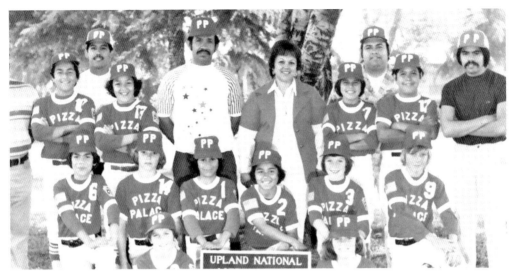

This is the Upland National Little League team in 1976. Mark Ramírez is in the second row, second from left. His cousin Manuel Cortéz (third row, fifth from left) and Richard Gómez (third row, sixth from left) inspired Mark to play baseball. Both were coaches and always took Mark to practice. This encouraged Mark to coach himself. He currently coaches his daughters in Rancho Cucamonga. Others on the team include Philip Valdez, Jamie Olivas, Eddie Limón, and manager Joe Ramírez (Mark's father). (Courtesy of Olivia Cortéz.)

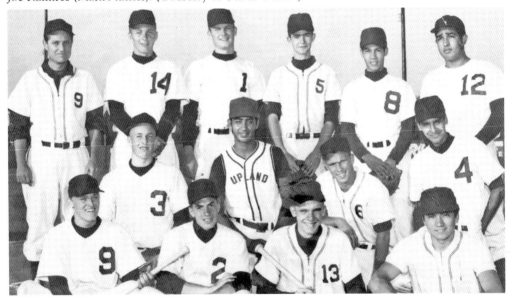

The 1962 Upland Colts Graduates played in the Inland Rookie League. Other teams in the league included San Bernardino American Legion Post 14, Rialto, Redlands, and the San Bernardino Rookies. The Colts had several Mexican American players, including Rey León (first row, far right), Tin Vásquez (second row, second from left) comanager John Viveros (third row, far right), Candy Solano (second row, far right), and Fernie Vásquez (third row, second from right). Not shown are Ralph Santos, Bob Ybarra, and Louie Morales. (Courtesy of Rey León.)

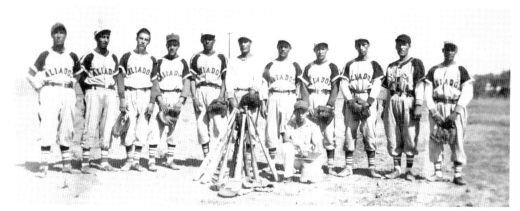

Manuel Oliva Pérez (third from right) was born in Riverside, California, in 1920. His father, Juan Pérez, moved to Riverside during the 1880s. Manuel taught himself how to pitch and to play several musical instruments. During the Great Depression, the United States implemented a repatriation program forcing over a million Mexicans and Mexican Americans back to Mexico. Manuel and his father purchased two new Ford trucks and headed to Mexico. Manuel played ball in Mexico with several teams, including Los Aliados. (Courtesy of Gilberto Pérez.)

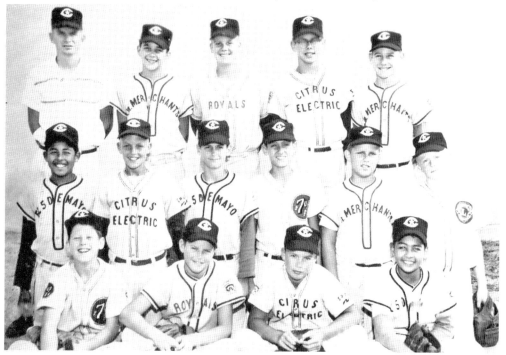

The 1958 Cucamonga All-Star team was coached by Alfonso Ledesma (third row, left). Gilberto Pérez (second row, left), the son of Manuel and Olivia Pérez, was an outstanding player, making the all-star team two years. Cucamonga played against all-star teams from Colton, Fontana, and Rialto. They played in the Western Regional Finals but were defeated by La Puente 1-0. Pérez still remembers that the winning pitcher was Mexican American. Rollie Fingers (second row, third from right) later became an outstanding pitcher with the Oakland A's. (Courtesy of Gilberto Pérez.)

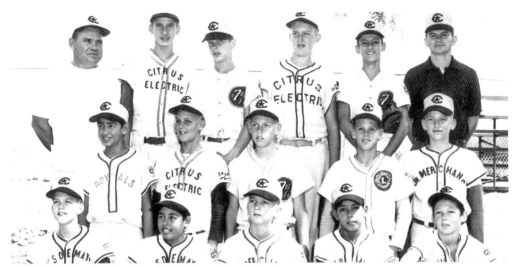

The 1959 all-stars played against Rialto, Fontana, Colton, and San Bernardino. There are three Mexican Americans on this team, including Gilberto Pérez (first row, second from left), Rex Robledo (second row, left), and Luís Santos (second row, second from right). Many of the Mexican American players played for the Cinco de Mayo team that played at Cucamonga Park behind Sweeten Hall. Their coach, Alfonso Ledesma (third row, right), was also their all-star coach. Standing next to Ledesma is Rollie Fingers. (Courtesy of Gilberto Pérez.)

In 1961, Gilberto Pérez (second row, left) led the Upland Pony League in home runs and made the all-star team as a pitcher and outfielder. On opening day, he hit the first pitch for a home run. The team played its games at Hawkins Field. Pérez was taught how to pitch by his father, who taught him the "drop" pitch known as a sinker today. He played eight years with Rollie Fingers, including high school. Also on this team are Johnny López and Gregorio Juárez. (Courtesy of Gilberto Pérez.)

The Zorros (Foxes) was one of the two original teams in 1960 that played for the Cucamonga Pony League. Alfonso Ledesma was one of the founders of both the Cucamonga Little League and Pony League. The Cucamonga teams played with teams from the Upland Pony League at Hawkins Field. Gilberto Pérez (first row, left) and Trinidad Campos (second row, second from right) were the sole Mexican Americans. Pérez recalled that Rollie Fingers (second row, right) liked to hang around with Mexican Americans. (Courtesy of Gilberto Pérez.)

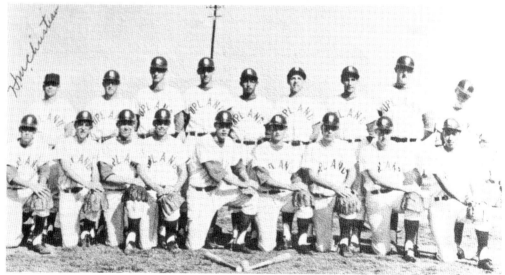

Gilberto Pérez and Rollie Fingers played at Upland High School. Pérez was the best pitcher and hitter on the freshman team, once striking out 18 Chaffey batters in six innings. In a preseason game, he struck out former major-league star Bobby Bonds. Upland was a member of the Tri-County League that included Montclair, Chaffey, Claremont, Chino, and Corona. Due to lingering discrimination, Pérez was dropped from the varsity team to the junior varsity, leading to a protest of several players, including Fingers. (Courtesy of Gilberto Pérez.)

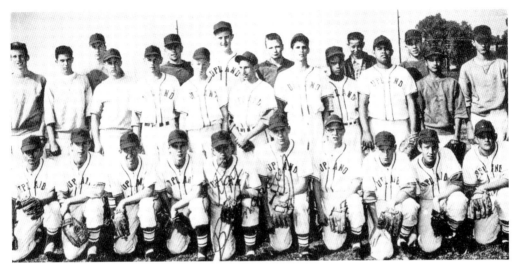

The 1961 freshmen team at Upland High School included Rey León (first row, left) and his cousin Manuel Cortéz (second row, third from right.) They played Little League and Colt and Pony Leagues, but this was the first time they had played on the same team. Cortéz was the catcher. Other players included Gregorio Juárez (second row, second from right), Bob Ybarra (second row, fourth from right), and coach Alonzo Powers (third row, second from right). (Courtesy of Rey León and Olivia Cortéz.)

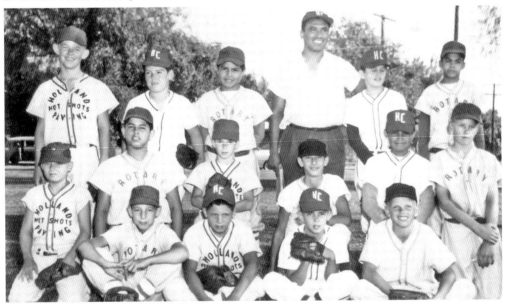

The 1958 Little League All-Star team in Upland included J. López, N. Mesa, B. Zavala, M. Cortéz, and A. Ramos, Like so many young boys of his era, Cortéz loved baseball, going to practice and the games. He taught his two sisters the game. Cortéz had no brothers, and being older than most of the kids, he formed teams at the schoolyard and encouraged the younger boys to join organize baseball. Cortéz was Rollie Fingers's bullpen catcher at Upland High School. Ernie Acevedo was manager. (Courtesy of Olivia Cortéz.)

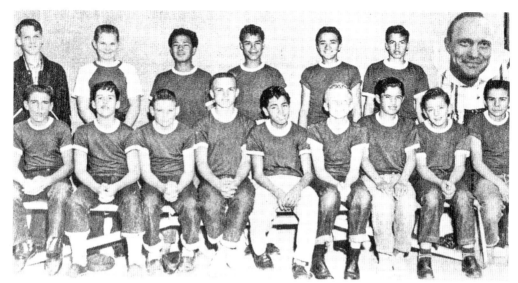

This is the Upland Junior High School "B" team around 1960. The team rivals included Ontario Junior High School, Vernon, De Anza, and Vina Danks. Most of these boys played baseball from Little League all the way through high school. They included R. Villanueva, B. Ybarra, D. Fernández, R. Duran, and Rey León. Rey León's family was from Mexico and settled in the Pomona Valley. As a kid, Rey picked lemons and still found time to play baseball. (Courtesy of Rey León.)

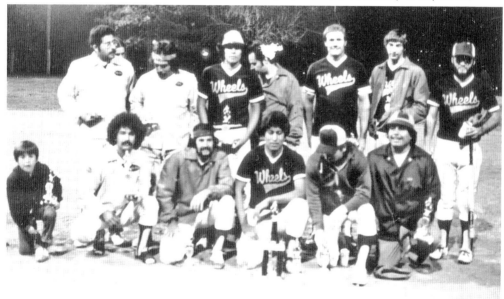

The Upland/Ontario Wheels team of 1978 played slow pitch, fast pitch, and baseball. Manuel Bocanegra, Gilberto Pérez, Joe Hernández, Armando García, Rick Von Kleist, and Mike Micaliff were all educators for 35 years or more. They taught elementary, middle, and high school, community college, and university. Two of the players, Pérez and Micaliff, were also high school administrators in the Fontana and Colton School Districts. Joe Hernández was a counselor at Chaffey College for more than 30 years. (Courtesy of Gilberto Pérez.)

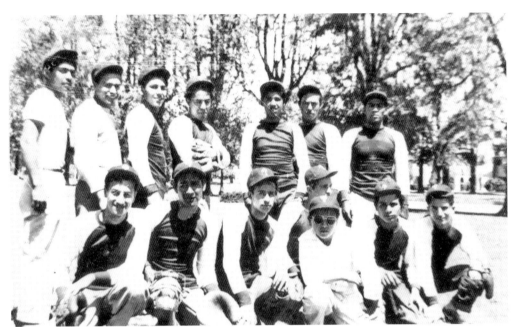

The Ontario Question Marks team was loaded with athletic talent. They defeated teams from Pico Rivera and Colton. They had loyal followers into the hundreds who attended their home and away games. This 1947 photograph was taken by manager Victor Ruiz. From left to right are (first row) Jesse López, Sam Razo, Severin R. López, Poncho Rangel, batboy Bobby Gracias, John Vásquez, and Pepe Franco; (second row) Raúl Najera, unidentified, Alfonso Villanueva, Lalo Olagués, Suki Marín, Richard Olagués, and David Arnulfo Villanueva. (Courtesy of Victor and Mary Ruiz.)

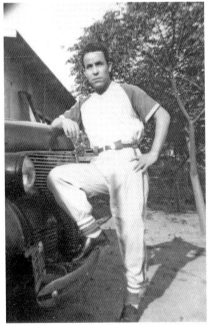

Lalo Olagués served during World War II as a military policeman and driver for high-ranking officers. He served in France, Germany, and Central Europe. Towards the end of the war, he assembled military gliders. He was with the 16th Depot Repair Squadron. Lalo returned to Ontario, playing for the Question Marks as a relief pitcher. They practiced at what is now Sam Alba Park in Ontario. He is leaning on his 1939 Chevy wearing his Question Marks uniform in 1947. (Courtesy of Lalo Olagués.)

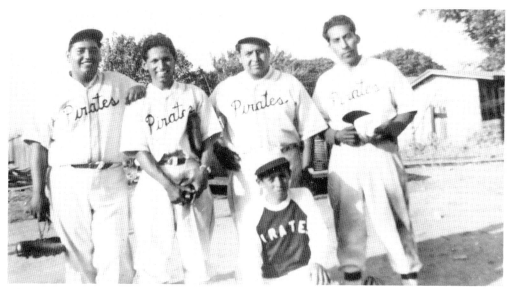

The 1946 Pirates were from the Upland-Ontario area, playing several teams from nearby Mexican American communities. They, along with five other teams, were part of the Mexican American Catholic League. The Pirates played their games in an empty lot on the corner of Grove Avenue and Bowen Street in Upland. From left to right are Arturo Valadez, Manuel Esebedo, unidentified, Paul Ynostroza, and batboy Tom Lucero Jr. Valadez had played ball in Mexico. His son, Ralph, later became an excellent player. (Courtesy of Anita Valadez-García.)

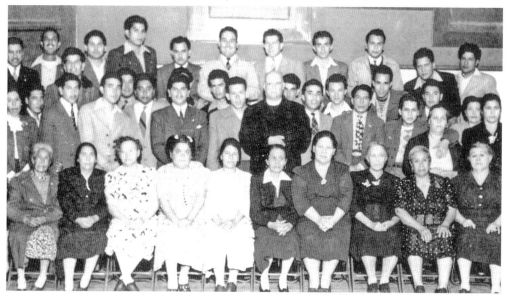

This 1942 photograph was taken inside the original Our Lady of Guadalupe Church in Ontario. The mothers were members of the Guadalupanas. The mothers prepared this going-away dinner for their sons and other young men going to fight in World War II. Many of the sons played for the Question Marks and another Fast-pitch team from Ontario, the Winos. Some of these players would later play ball in the military. Father Sánchez is the priest in the middle. (Courtesy of Lalo Olagués.)

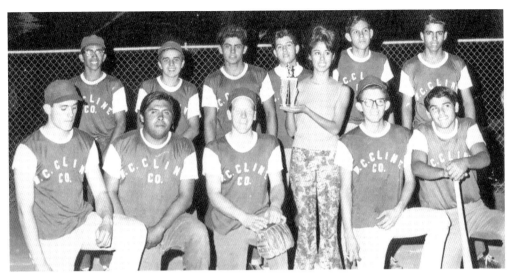

This 1965 Mexican American team won the Upland League Championship, beating teams including Citrus Motors comprised of college players from Chaffey and the University of California at Riverside. Most of the players originated from the Bowen Street Barrio in Upland, and many lettered in varsity baseball at Upland High School. From left to right are (first row) Rene Andazola, Andy Belmontes, Bo Crossland, Diane Caindec (holding championship trophy), Albert López, and Richard Morales; (second row) Manuel Meza, David Meza, Ángel Morales, Ernie Pérez, and Danny and Marty Rivera. (Courtesy of Richard Morales.)

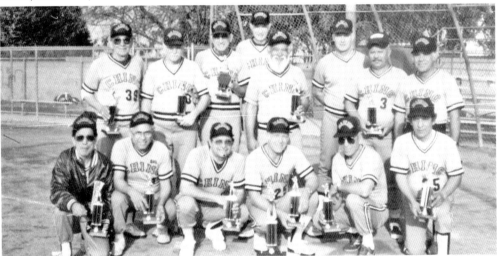

The Chino Hawks senior team was formed in 1982. The Hawks are comprised of players who played youth ball, in high school, college, community, and business teams, and in church leagues. The Hawks have won several championships and tournaments. The team has produced many outstanding players, including George, Tommie, and Maury Encinas, Louie and Gilbert Guevara, Martín Salgado, Victor and Sal Martínez, Paul Yamas, Jess Briones, Bobby Duran, Charlie Aguilera, Bobby Dueñas, and Raúl Carnica. Mexican Americans comprise a significant percentage of senior softball players. (Courtesy of Stella Guevara.)

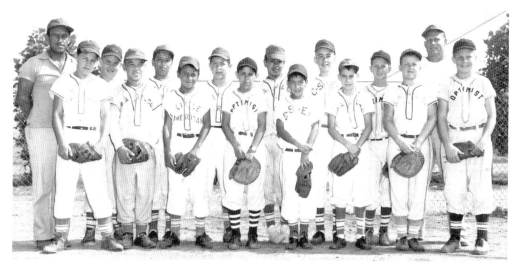

Amado Briones (far left) coached this team of Chino all-stars, including his son Amado Jr. (fifth from left). Amado Jr. was an extraordinary athlete. He was an all-star in both Little League and Pony League, he hit the longest homerun in Pony League history at Hawkins Field in Upland, he was a shortstop and pitcher on the Chino High School varsity team for three years, and he also played two years of high school football. He had a tryout with the Dodgers by scout Lefty Gómez. (Courtesy of Chuck Briones.)

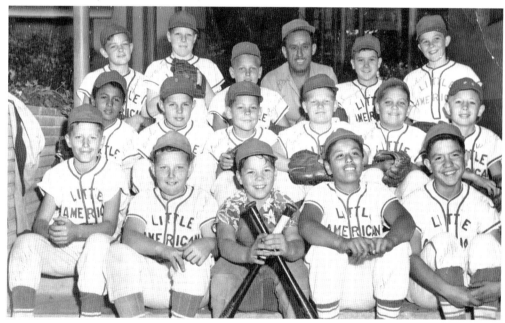

Chuck Briones (not shown), the brother of Amado Jr., played in Little, Pony, and Colt Leagues. He played junior varsity baseball for two years and varsity basketball for two years at Chino High School. Chuck coached with his father Amado for seven years. Later, Chuck umpired Little, Pony, Colt, and Palomino Leagues. In this photograph are Amado Sr. and Amado Jr. The Briones family has continued to produce a new generation of players. (Courtesy of Chuck Briones.)

3

MILITARY BASEBALL

This extraordinary chapter pays tribute to Mexican Americans who played ball in the armed forces. Besides defending their nation during war and peace, these men and women participated in the national pastime, bringing enjoyment and entertainment to their fellow servicepersons. Several played baseball while engaging the enemy in World War II, the Korean War, and Vietnam. Sadly, some were killed on the battlefield. Mexican Americans have clearly distinguished themselves and erased any lingering doubts about their loyalty to the United States. These men and women enlisted in all branches of the military and were stationed around the globe. World War II, Korea, and Vietnam marked political and social turning points, as returning Mexican American servicemen and women were now determined to win, once and for all, their right to full American citizenship at home.

Mexican American women played a major role both on the home front and in the military. They worked as defense workers in steel mills, railroads, aircraft plants, packinghouses, munitions plants, and agriculture. Some women eventually joined the military during World War II, Korea, and Vietnam. Other Mexican American women collected scrap iron, planted Victory Gardens, organized civil defense neighborhood groups, sold war bonds, became nurses, worked with military intelligence, entertained troops, and aided in language translation during World War II and Korea.

Nearly all of these men and women highlighted in this chapter, many from the Pomona Valley, had played baseball and softball prior to joining the military, playing youth ball, in high school and college, in community and church teams, for local merchants, in Mexico, and professionally. After their military service ended, the majority of them continued playing ball, some into their late senior years. Mainstream baseball history has often neglected the baseball and softball contributions of Mexican Americans in the United States, with almost no mention of their immense contributions of playing ball in the military. This chapter, the first of its kind ever, takes the first small step to remember and honor those who played the game they loved so much while risking their lives for all of us.

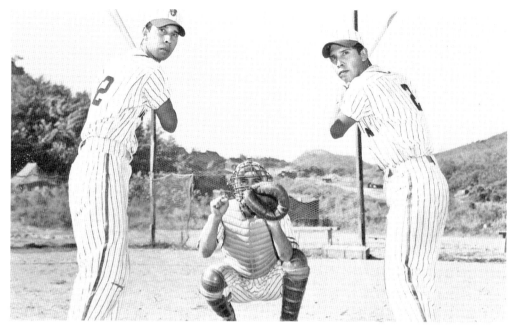

Ernie (left) and Manuel Abril (right) once escorted Marilyn Monroe in 1953 during her visit to entertain the troops in Korea. They were born and raised in South Colton, California, where they played lots of baseball as outfielders with several teams, including the famous Mercuries. They played in Mexico during the winter, where they hung out with legendary singer Pedro Infante. They were known all their lives as Los Cuates (the twins). They both reside in Colton. (Courtesy of April Abril and Ray Rodríguez.)

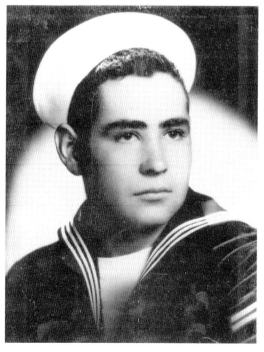

Art Gallego Amarillas, from Santa Maria, California, joined the Navy Reserve in 1956. In 1958, he was called to duty and sent to Guam on the USS *Banner*. While in Guam, he played baseball on the Island team. One of his teammates was Ben Reyes, one of his hometown friends. Art played both catcher and pitcher. He played against the 1959 US All-Stars going to Japan and had drinks with New York Yankee Whitey Ford after a game. (Courtesy of Art Gallego Amarillas.)

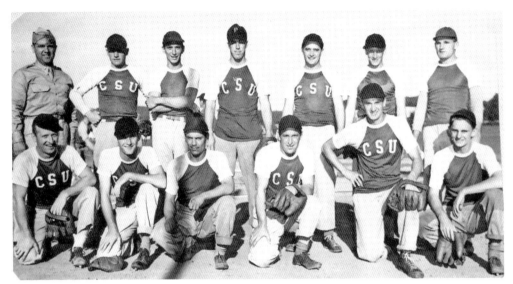

Joe Andrade had an extraordinary sports career in Calexico, California, where he starred in several sports. In high school, he pitched a three-hit victory over San Diego's Hoover High School, striking out Ted Williams. He received a scholarship from the University of Southern California and also played professional ball in Mexico. Joe was a Marine who fought in World War II. Joe (first row, third from left) formed a team at Camp Richie for returning veterans in 1944–1945. (Courtesy of Rosemary Andrade and Steve Binder.)

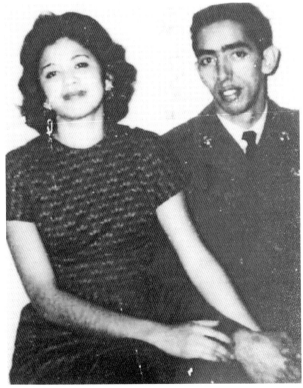

Remi Álvarez played ball at Jefferson High School in Los Angeles in 1953 and 1954. He completed his basic training at Fort Lewis, Washington, and was assigned to Fort Campbell in Kentucky, where he trained as a paratrooper with the 101st Airborne. He played for the base team, known as the Geronimos. Remi remembered two other Mexican American ballplayers, Marty Martínez from San Jose and ? Zarate from Huntington Park. He is seen here with his wife, Lydia. (Courtesy of Remi Álvarez.)

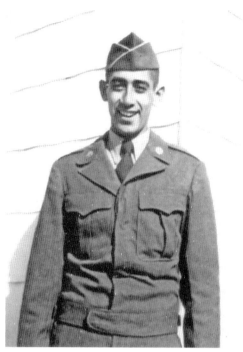

Richard Álvarez played baseball at Manual Arts High School in Los Angeles in 1946–1947. He was signed by the Cleveland Indians and played minor-league ball for the Class C Yuma Panthers. He was on his way to a game in Porterville, California, when he learned he had been drafted. Richard did his basic training at Fort Ord, California, before being sent to Korea in 1952. He saw action on the battlefield and still found time to play for the division baseball team at third base. (Courtesy of the Richard Álvarez family.)

Art Álvarez played baseball at Jefferson High School in 1953 and was voted into the Helms Athletic Hall of Fame, the first Mexican American inducted in the hall. He was signed by the Cleveland Indians. He signed up for the service and was sent to Fort Ord before being assigned at Fort MacArthur in San Pedro, California. He played second base for the team. Art's team played for the championship game at Fort Dix, New Jersey. Remi, Richard, and Art are brothers. (Courtesy of the Art Álvarez family.)

Cuno Barragán (first row, fourth from left) was a baseball star from Sacramento, California. He joined the Navy Reserve during the Korean War and did his reserve training at the Naval Training Center in San Diego. He was transferred to the 13th Naval District in Idaho. Cuno played baseball for the San Diego Navy Bluejackets. As a Chicago Cub, he once had a hit off of Sandy Koufax. Raymond Hernandez (first row, second from right) pitched for the University of Southern California in the early 1950s. (Courtesy of Cuno and Karla Barragán.)

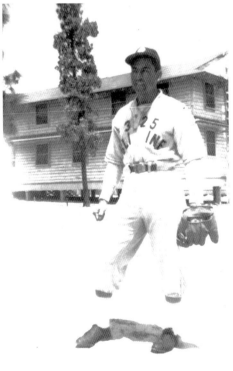

Jess Briones from Chino, California, joined the US Army in 1944 and completed his basic training at Fort Roberts in California. He was about to be shipped out to the Philippines when Japan surrendered. He later served in Japan, France, and Germany. He played for several teams, including the 503rd in the Philippines, the 508th in Germany, and the 325th and 504th in North Carolina. He played shortstop and outfield for the Fort Bragg All-American team. (Courtesy of the Briones family.)

David Paul Camacho (first row, second from right), from Santa Ana, California, played for the 1951 baseball team at Two Rock Ranch Station at the Petaluma, California, military base. Since he spoke several languages, including Russian, he served as a translator in the Army Security Agency. (Courtesy of Mary Camacho.)

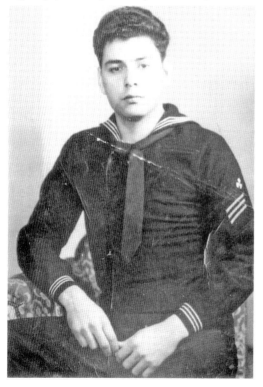

Ralph Castañeda Jr. joined the Navy in 1948 and attended boot camp in San Diego. He was sent to Guam and started playing shortstop in 1949. Ralph was selected to play in his military district team due to being an excellent player. He received several ribbons, including for China Service and Korean Service with three stars. He was born and raised in Scottsbluff, Nebraska. (Courtesy of Ralph Castañeda Jr.)

Marcus L. Castillo was known as the "King of the Homerun" in the San Fernando Valley. He was stationed in the Philippines during World War II with the Army. In 1945, he was sent to Japan, where he played interleague baseball. In 1947, he was discharged and came home, where he continued to play both baseball and softball for several teams, including the Classy Cats. (Courtesy of Nellie R. Medellín and Ramona Cervantes.)

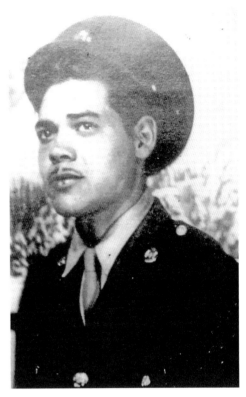

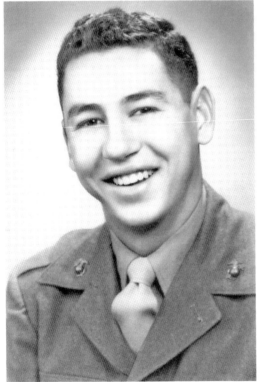

Rudy Castro grew up in Barrio Anita in Tucson, Arizona. He was captain of his high school team, which won three consecutive state championships from 1947 to 1949. In 1951, he and 1,000 prospective young soldiers tried out for the 21 slots on the Camp Pendleton baseball team. Three Mexican Americans made the team. They traveled extensively throughout the United States, playing against other Marine Corps bases and college teams, including the University of Arizona Wildcats. Between 1951 and 1953, the Camp Pendleton teams won the West Coast Championship. (Courtesy of Linda Castro Spencer.)

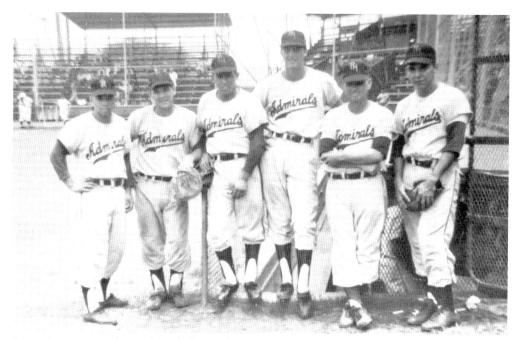

Ernie Cervantes Jr. (third from left) was born in Sacramento, California. In 1960, he received his basic training at the Naval Training Center in San Diego. He was assigned to Pearl Harbor, Hawaii, and to the Admirals baseball team, part of the Hawaii All Service Military League. Ernie had various duties including harbor patrol and raising and lowering the colors on the USS *Arizona*. He was later assigned to the USS *Forester* and cruised the Bering Straits monitoring the Russian fleet. (Courtesy of Ernie Cervantes Jr.)

Ernie Cervantes Sr., the father of Ernie Jr., also played ball in the service. It is extremely rare to find a father and son who played ball in the military. Ernie Sr. was stationed in Guam during World War II between 1943 and 1945. He is shown here in his baseball uniform. On Guam, he was a truck driver, athletic director, and coach for the baseball team. On his team were major-league stars Phil Rizutto of the New Yankees and Pee Wee Reese from the Brooklyn Dodgers. (Courtesy of Ernie Cervantes Jr.)

Elías De La Rosa Jr. was raised in East Los Angeles, California, and drafted into the Army in 1968. He did his basic training at Fort Ord and was assigned to Fort Bliss, Texas. He made the military team (the only Mexican American to do so) and played outfield and third base. After playing only four games, he received orders to Vietnam, where he was stationed at Chu Lai with the 23rd Infantry near the North Vietnamese border. He was assigned to the antiaircraft unit. (Courtesy of Elías De La Rosa Jr.)

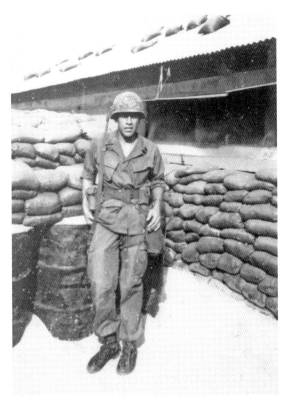

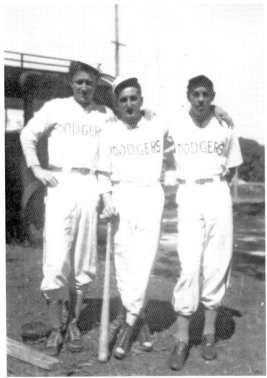

Ray Delgadillo was born in Dewey, Oklahoma, in 1920, and later the family moved to Corona, California. Ray was drafted into the Army in 1942 and was stationed in Australia, New Guinea, and the Philippines. He was with the 40th Intelligence Communications, a global radio relay system. Ray (right) and other servicemen created baseball teams as a form of leisure in Brisbane, Australia. His teammates decided to call themselves the Dodgers after the Brooklyn Dodgers. (Courtesy of Ray and Hillie Delgadillo.)

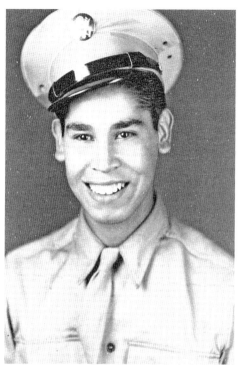

Tommie Encinas, from Pomona, California, departed to Hammer Field in Fresno in 1943. He trained at Fort Lewis in Washington, Leesburg Army Air Field in Florida, and in San Francisco, where he received his technical training at the US Army Medical School. He was given a letter of recommendation to pursue a career in medicine but chose to play baseball in the military. He was assigned overseas duty in Okinawa and served as a medical corpsman. His last unit was with the 1885th Engineer Aviation Battalion. (Courtesy of the Encinas family.)

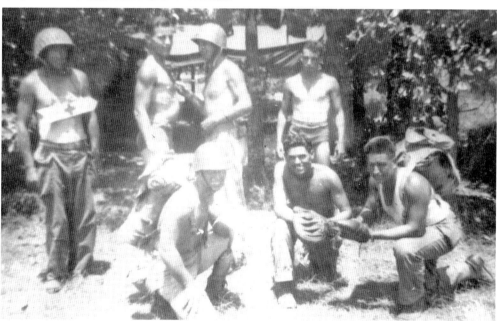

Manuel Hernández (first row, far right) served in World War II as a medic and saw action in Germany, Belgium, and Holland. His nickname was "Smoothie" among his fellow soldiers because of his sweet swing of the bat. He had an outstanding baseball career before and after the war in Los Angeles. His future mother-in-law, Carmen, ran the Lupita Inn restaurant, which sponsored a baseball team. He joined the team, and that is how he met his wife, Sally. (Courtesy of Sally Hernández.)

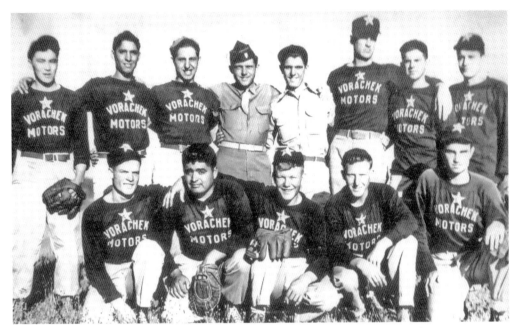

Emidio "Milo" Hernández (second row, far right) is seen here in Seattle, Washington, in 1944, when he trained with the infantry and with special services. He played baseball and boxed in the service. He was not sent overseas due to a brother, Sergio, who was killed in action and another brother, Manuel, in combat. Prior to and after World War II, Milo played many years of Los Angeles community and industrial baseball. He is seen here with the 23rd Infantry championship team. (Courtesy of Sergio Hernández.)

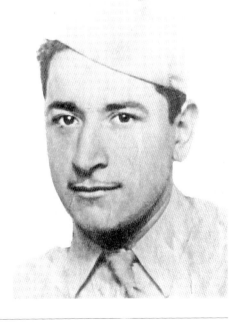

Sergio Hernández was raised in Los Angeles. He played baseball as a youth and at Jefferson High School in 1938. He enlisted in the military along with his two brothers, Manuel and Milo. Sergio was assigned to the "Yankee Division" with a National Guard unit and was killed at the Battle of the Bulge on his 21st birthday. He is buried in Luxemburg. His sister-in-law Sally recounts that there was a contract waiting for him from the New York Yankees when he returned. (Courtesy of Sergio Hernández.)

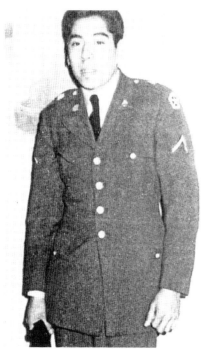

John Hernández, from Irwindale, California, was in the Army from 1963 to 1965. After his basic training at Fort Ord, he went to Fort Sam Houston Medical Training Center in San Antonio, Texas. John played company-level fast-pitch at various time during his training and played fast-pitch softball while stationed in Wildflecken, Germany, with the 54th Combat Engineer Battalion as a medic specialist. (Courtesy of John Hernández.)

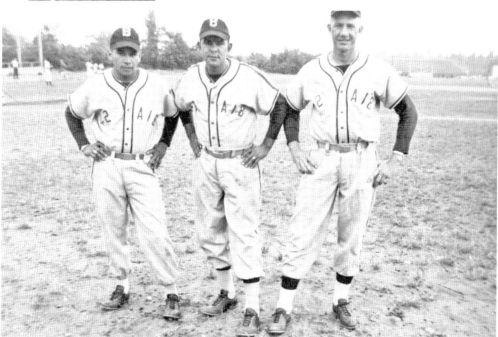

Louis Jiménez (center), from Modesto, California, played in Germany in 1956. Louie had four brothers who served during World War II, including Prospero, who earned two Purple Hearts and the Bronze Medal. A fifth brother, Félix, served in Korea, while Tilo and Louie served during peacetime. Louie reported to military duty only two days after he married Elvera. Louie played lots of baseball in Riverbank, Modesto, and Oakdale. (Courtesy of Louis and Elvera Jiménez.)

Art Lagunas played football, basketball, and baseball at El Rancho High School in Pico Rivera, California, in the 1950s. Art played baseball with his brother Bob at Orange Coast College (OCC), where he was the team captain in 1959. In 1962, Art joined the US Army and completed his basic training at Fort Ord in California and was then assigned to Fort Bragg, North Carolina, as a member of the 82nd Airborne, 101st Battle Group, 187th Infantry. He played two years of military baseball. (Courtesy of Bob Lagunas.)

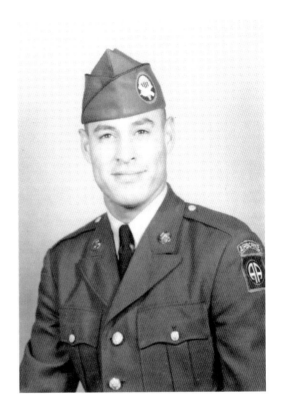

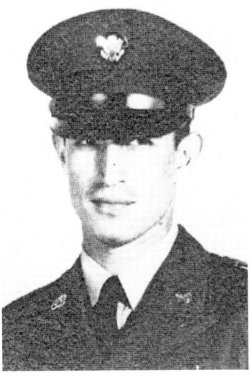

Bob Lagunas was raised in Pico Rivera, California, playing ball at all levels. Bob completed his basic training at Fort Ord in California. He played ball at Fort Clayton, the former US Army base in the Panama Canal. He was with the Caribbean Command, Company B, 4th Battalion Mechanized, 20th Infantry. His team played against teams throughout Central and South America, including Ecuador, El Salvador, Costa Rica, and Panama. The US team included two Mexican Americans and three Puerto Ricans. (Courtesy of Bob Lagunas.)

Margaret Villanueva Lambert was raised in Lincoln, Nebraska. Before World War II, she played on softball teams and remembered playing against several other Mexican American women's teams throughout Nebraska. Margaret enlisted in the Women's Army Air Corps (WAAC) during World War II. She was a driver and chauffeured the top brass around the base. When the war ended, Margaret was sent to San Antonio, Texas, to organize sports activities for returning veterans to help them adjust to civilian life. (Courtesy of Margaret Villanueva Lambert.)

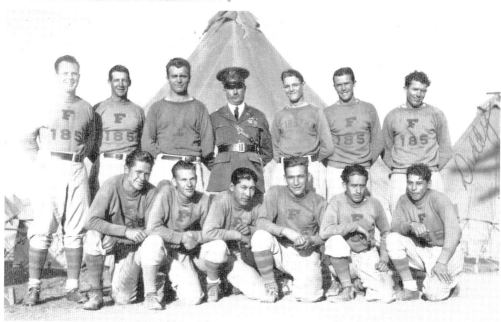

Frank Layvas (first row, far right) played for the National Guard Armory baseball team in Pomona, California, in 1933. His unit, the 185th Infantry, 80th Brigade, had several outstanding players. His wife, Ellinor Magub Layvas, drove trucks and cars for the National Guard, driving high-ranking officers around the Pomona area. She was from Sioux Falls, South Dakota, and met Frank in Pomona. (Courtesy of Cindy Swartwood.)

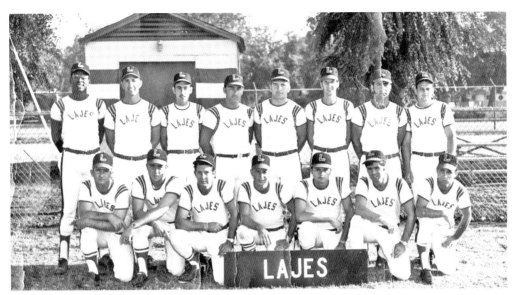

Sam León (first row, third from right), from Upland, California, did his basic training at Lackland Air Force Base (AFB) in San Antonio and served at Sheppard AFB in Wichita Falls, Texas, Norton AFB in San Bernardino, and Barksville AFB in Shreveport, Louisiana. He was later stationed in the Azores Islands, nearly 1,000 miles from Portugal, where he played on a military fast-pitch softball team. The team, Lajes, is seen here at the Military Airlift Command 1970 Softball Championships. (Courtesy of Sam León.)

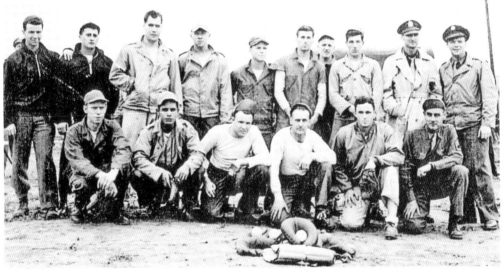

Ramón A. Martínez (first row, second from left) was born in Copeland, Kansas. In 1944, he was assigned to ground crew status as a wing armorer with the 434th Fighter Squadron, 479th Fighter Group, Eighth Air Force. His group was sent to Wattisham Air Force Base in England to begin air operations against Hitler's Luftwaffe. The curator of the Wattisham Air Museum has requested Ramón's photographs be included as part of an exhibit dedicated to American servicemen of the 479th Fighter Group. (Courtesy of Rod Martínez.)

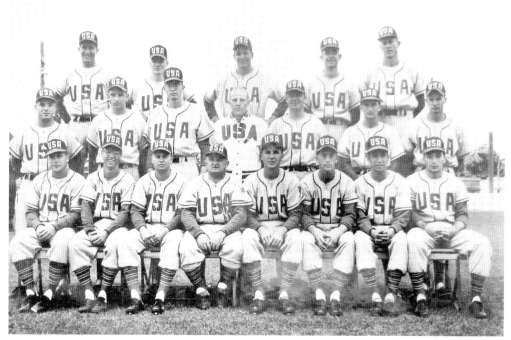

Rudy Salvador Martínez, from Lompoc, joined the Marine Corps in 1956 and did his basic training at the Marine Corps Recruitment Depot in San Diego. He was sent to Camp Pendleton and then to Camp Hague in Okinawa. He helped his team win the 3rd Marine Division Championship in the Far East and was voted MVP for the tournament. Rudy (first row, second from right) played for the US team in the 1956 Goodwill Olympics in Melbourne, Australia, including one game before 109,000 fans. (Courtesy of Rudy Salvador Martínez.)

Richard Méndez, from Santa Ana, California, enlisted with the California National Guard at the age of 16. When the Korean War broke out, his unit, Company I, 224th Regimental Combat Team, 40th Division, was activated. He pitched for the Regimental League and led his team to the finals, but his unit was sent to the battlefront before the game. In 1952, his unit played in their fatigues for the championship. Richard came in relief and gave up no runs, but his team lost 3-0. (Courtesy of the Méndez family.)

Albert Moreno was born in Irwindale, California. In 1962, he joined the Army with his good friend Art Tapia under the buddy plan. They did their basic training at Fort Ord in California and were later assigned to Fort Gordon, Georgia, playing for the fast-pitch softball team. Albert was an excellent second baseman, while Tapia was the number-one pitcher and the team's MVP. Both of them were shipped to Korea and eventually returned to Fort Bragg, North Carolina. (Courtesy of Albert Moreno.)

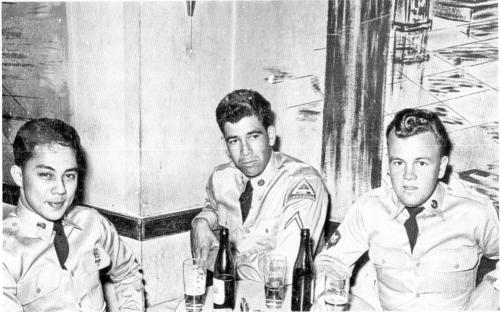

Buddy Muñoz (center) served in the US Army between 1957 and 1959. He took his basic training at Fort Ord, California. He was assigned to Huntsville, Alabama, at Redstone Arsenal, a top-secret location where captured German scientists were housed after World War II. Buddy was part of the Seventh Army's Ordinance Detachment. He was stationed in Kitzgen and Karlsruhe, Germany. In Germany, he played for two company teams as a pitcher and at first base. Their opponents were army units throughout Germany. (Courtesy of Buddy Muñoz.)

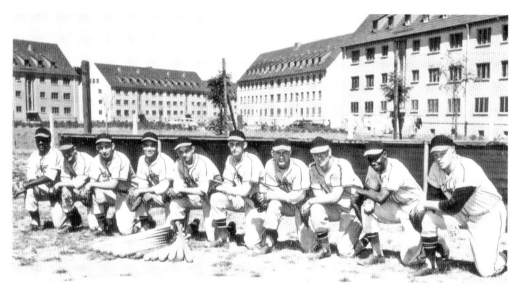

Gabe Peña was raised in East Los Angeles. He completed his basic training at Fort Ord in California and was stationed at Kirchgons Base in Germany near Frankfurt for 18 months. His unit was the 4th Division, 22nd Infantry, working with mortars. Gabe (fourth from left) was a catcher for the team playing against teams including the 8th Infantry, 12th Infantry, Division Artillery, and Special Troops. Besides baseball, Gabe was the quarterback for the football team. He helped with boxing matches and basketball games. (Courtesy of Gabe Peña.)

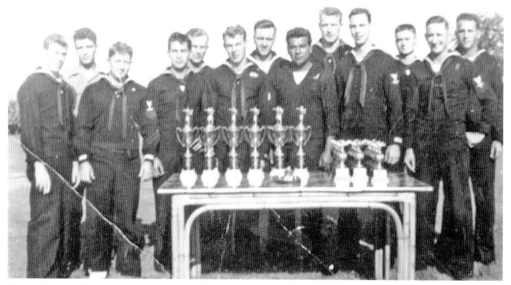

Frank Prieto (first row, third from right) was born in Banning, California, and raised in Palm Springs. He joined the Navy and was stationed at Moffett Field in Sunnyvale, California. He pitched for his service team and became close friends with Ray Salazar from New Mexico, who managed the team. They were teammates in Hawaii and other locations in the Pacific. Despite living in different states, their incredible friendship endured until 2011, when Prieto passed away. (Courtesy of the Frank Prieto family and Ray Salazar.)

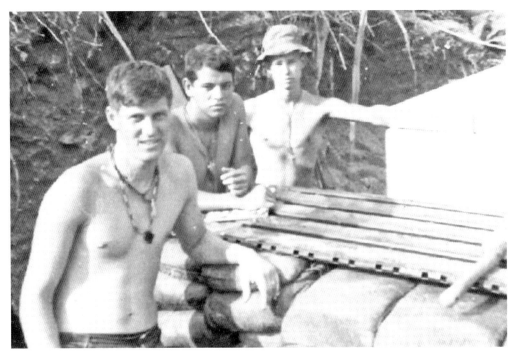

Alfonso Olmos (center) was drafted by the San Francisco Giants and the US Army. He did his basic training at Fort Ord in California in 1968 where he played ball before being shipped to Vietnam with the 506th, 101st Airborne Division. He was an infantryman in the Ashau Valley in Thau Thien Province. Alfonso kept his Giants contract in his helmet. He was killed in action on July 19, 1969. The movie *Hamburger Hill* depicted the battle where he lost his life. (Courtesy of David Olmos.)

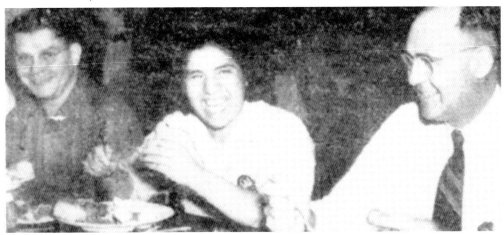

Juanita Conchola grew up in Davenport, Iowa. Juanita worked at an ammunition plant during World War II. In 1943, she joined the Women's Army Corps. She took basic training at Fort Des Moines and attended navigation school in Hondo, Texas. While in the service, Juanita played softball, basketball, and tennis. She played shortstop, beating the Waves, the Lady Marines, and teams from the Luke and Williams Air Force Bases in Arizona. (Courtesy of Juanita Conchola.)

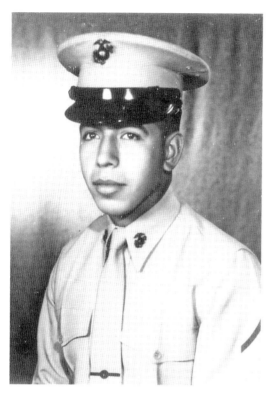

Ben Reyes was born in Guadalupe, California, and served in the US Marine Corps from 1956 to 1960, receiving his basic training at Camp Pendleton, California. While stationed in Guam, he joined the baseball team and played the outfield. Later in life, Ben coached Little League for 25 years, including coaching his two sons, Richard and Jonathan. He was a lifelong fan of the Cleveland Indians and USC Trojans. (Courtesy of Ramona Reyes.)

Ray Salazar was raised in Albuquerque, New Mexico. He joined the Navy in the early 1950s and played at Moffett Field in California for two years and two years at Barbers Point, Hawaii. In this photograph, Ray is receiving the MVP award and certificate in 1953. After the service, he played for many years in New Mexico, including senior ball. In one game with the Armed Forces League, he scored three times against the CincServPac Admirals. (Courtesy of Ray Salazar.)

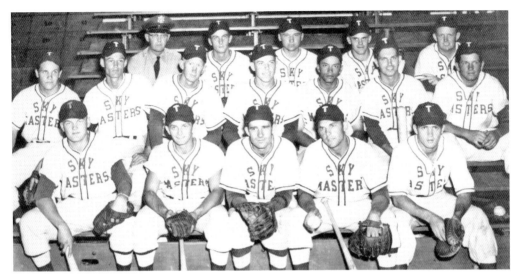

Charlie Sierra (second row, third from right) was raised in East Los Angeles, California, and played at Travis Air Force Base in California in 1952 with the 14th Air Division. The Skymasters won the California and Pacific Championships in 1952 against the Hickam Flyers. The Skymasters played in the World Wide Air Force Baseball Championship at Eglin Field in Florida. In 1951, Charlie played for the Yokota Raiders, which won the Far East Air Force Baseball Championship at the Tokyo Coliseum. (Courtesy of Charlie Sierra.)

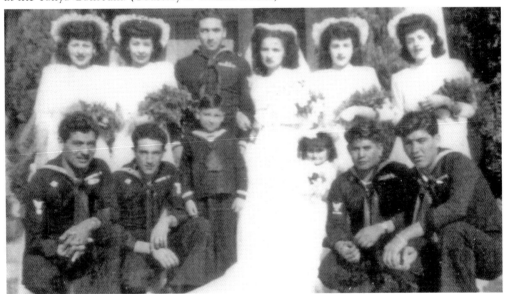

Fidel Solíz (first row, second from right) was raised in Hicks Camp in El Monte. He played against Jackie Robinson in pickup games and became a close friend of Robinson. Robinson invited Fidel to play for a short time in the Negro Leagues. In 1943, he was assigned to the destroyer USS *Harrison*. Fidel manned a five-inch gun in action throughout the Pacific. Fidel played ball for the US Navy in World War II. The *Harrison* was sold to the Mexican navy in 1968. (Courtesy of Lucy Pedregón.)

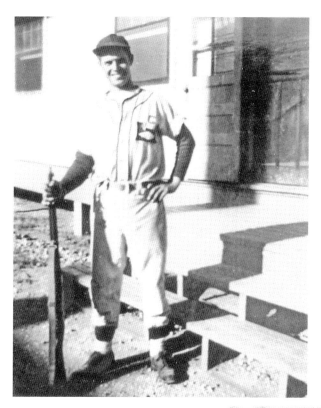

Frank Briones from Fresno played ball during the 1950s and continued playing baseball into the 1960s and 1970s. He served in the US Army and played baseball during his tenure in the armed forces. He is shown here in front of his barracks with his baseball uniform and service rifle. He played for the love of the game as well as serving his country. While he is no longer alive, he is fondly remembered by his family and the Fresno community. (Courtesy of David Trujillo.)

Paul Trujillo was born in Azusa and joined the Marines on the buddy plan with his friend Henry Toledo. They did their basic training at the San Diego Marine Corps base when news arrived that the Japanese had bombed Pearl Harbor. Both served four years and seven months in the Pacific. Paul and Hank played on the Marine baseball team in Guadalcanal and were part of the Marine league that played ball throughout the Pacific, including New Zealand and Bougainville. (Courtesy of Henry Toledo.)

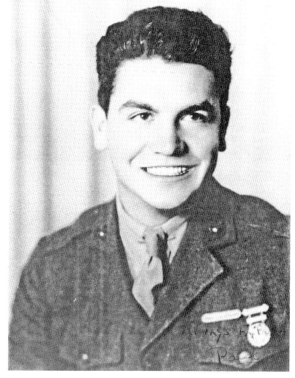

Art Tapia Jr. (in baseball uniform) was raised in Irwindale, California. He served in the Army Airborne. His pickup team defeated the top-rated military team during basic training. He was asked to play for the military team but turned down the offer because he did not want his friend to go to Korea alone. He played ball in Korea during the 1961–1962 season and was the only pitcher on the team, pitching every game. Art had his mom send his baseball cleats to Korea. (Courtesy of Art Tapia Jr.)

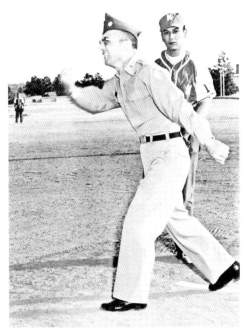

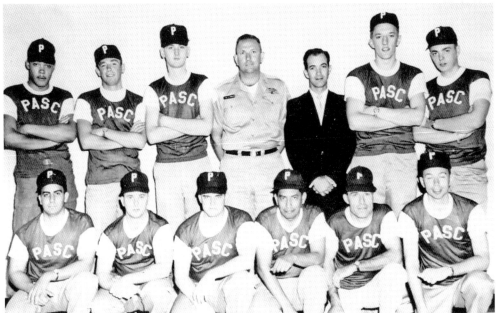

Henry Toledo (first row, third from right), from Azusa, California, joined the Marines in September 1941. Three months later, Japan attacked Pearl Harbor. He was stationed in Pearl Harbor in early 1942 and saw action at Guadalcanal, Tulaguie, and the Bougainville Islands. He played on the Marine team. He left the Marine Corps in 1945 but joined the Army in 1950; he saw action in Korea and played several sports with the 47th Artillery Brigade. (Courtesy of Henry and Cecilia Toledo.)

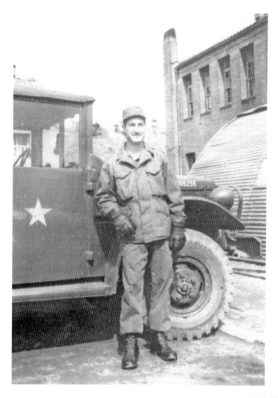

Carlos Uribe, from Corona, California, was assigned to the 304th Signal Corps Battalion in South Korea in December 1952. The following June, Uribe's unit organized a team in the Seoul City Command League. A pitcher and outfielder, Uribe recalled that he was the only Mexican American on an all-Anglo team. He once led the team in hitting average. He played for one season before returning home in 1954. (Courtesy of Carlos Uribe.)

Luis Uribe was born in Corona, California, and was a catcher for his military team in Orleans, France. His three brothers, Alfredo, Jose, and Carlos, were talented players for the Corona Athletics, a powerhouse baseball team in the Inland Empire from the 1930s through the 1950s. Besides playing ball, all four worked together as citrus pickers. All of the brothers were signed by major-league baseball organizations. (Courtesy of Carlos Uribe.)

Joffee García Jr. was raised in North Hollywood. He completed basic training at Fort Ord in California in 1966 and was assigned to Fort Wainwright, Fairbanks, Alaska, with the 559th Combat Engineering. Company. Temperatures ranged from 30 to 70 below zero. In 1968, Joffee played for one of the company's baseball teams. They were not able to finish their season due to the nearby conflict with Russia during the Cold War. Joffee was later discharged from the service at Fort Lewis, Washington. (Courtesy of Joffee García Jr.)

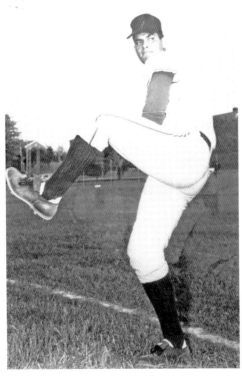

Ray Sevilla was an outstanding athlete from Claremont, California, in baseball and football. He was assigned to Fort Devens in Massachusetts in 1964 and pitched for Company C, 1st Battalion, 2nd Brigade. The team went on to win the championship. The following year, Ray was averaging two strikeouts per inning. Due to the escalation of the Vietnam War, special services, including baseball, were discontinued. Ray was sent to Phouc Vinh, Vietnam. His father, Ramón, had served in World War II, including combat at the Battle of the Bulge. (Courtesy of Ray Sevilla.)

Robert Alba was born in Pasadena and raised in Simi Valley, where he and his family worked in the orchards. Robert enlisted in the US Army to join his brothers Mike and Soupiano. Robert served in World War II and in Korea in Company B, Battalion 226, Military Police 519 and served in the special services as an all-star pitcher. When Robert was stationed in Guam, his team traveled to the Philippines and Hawaii to play against military all-star teams. He states, "It was good times to get your mind off the war." (Courtesy of the Alba family.)

José Hermosillo, from Claremont, California, did his basic training at Fort Ord in California in 1966. He was sent to Fort Bliss in Texas as a Hawk missile mechanic. He was assigned to Fort Hood as quartermaster for food dispensing. José was shipped to Mannheim, Germany, as a helicopter mechanic. He played shortstop for the 582nd Transportation Division base team, called the Rollers. After the service, he led his San Bernardino Padres team to a championship and won the MVP award. (Courtesy of José Hermosillo.)

Paul Gómez was raised in Claremont, California, playing baseball. His brother, Tony, was an outstanding pitcher. Both joined the US Army during World War II. Immediately after the surrender of Japan, both Paul and Tony were in Japan as part of the occupational forces. Paul traveled 100 miles to visit Tony in Tokyo. Paul played military baseball and played in Kobe, Tokyo, and other cities. At home, he and Tony played for the Claremont Athletic Club. Paul retired from the Claremont Police Department. (Courtesy of Rudy Gómez.)

Ignacio Félix grew up in Claremont, California, and played years of baseball before entering the Army during World War II. He did his basic training at Fort Lewis in Washington with the 101st Airborne. He was then assigned to the US Army Service Forces Medical Corps at Letterman Hospital in San Francisco. He played third base for the Sixth Army team. He was transferred to Fitzsimons General Hospital in Denver, Colorado. After returning home, he played baseball for a few more years. (Courtesy of Ignacio Félix.)

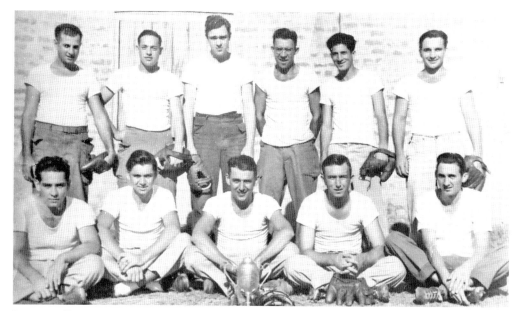

Jesús Paz (first row, left) served in World War II in the China-Burma-India campaign. He is seen here with a softball team in Calcutta, India, in 1945 with the 142nd Regiment of the US Army. This team won the Calcutta Softball Championship. Jesus was an outstanding player during his youth and coached many years, often referred to as "Mr. Boyle Heights" because of his tireless efforts coaching and maintaining the fields and parks for the youth. (Courtesy of Kevin Paz.)

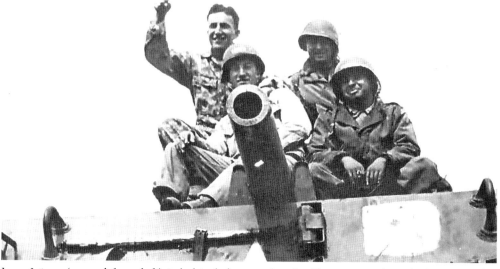

Jesse López (second from left) is behind the muzzle of a Sherman tank with Gen. Douglas MacArthur's forces when they retook the Philippine Islands from the Japanese. He did not play organized ball in the military but was assigned to organize softball games among the troops between battles with the Japanese. A number of Mexican Americans, who had baseball experience, were assigned to coordinate baseball activities during World War II. Jesse later became an outstanding player for the Ontario Question Marks. (Courtesy of Lorraine López Morales.)

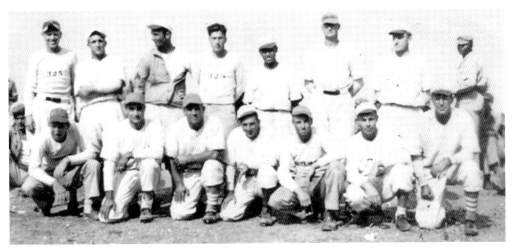

Jess Trujillo grew up in Pomona, California, and played ball as a youth and at Pomona High School, where he was a teammate of Tommie Encinas. He enlisted in the Air Force and was stationed in North Africa with the 325th Fighter Squadron. Between missions, the ground crews played ball. Jess (second row, center) played second base. He returned home severely shell-shocked. He never married nor had children. His nephew, Buddy Dueñas, followed in his uncle's footsteps playing youth, school, and semipro ball. (Courtesy of Buddy Dueñas.)

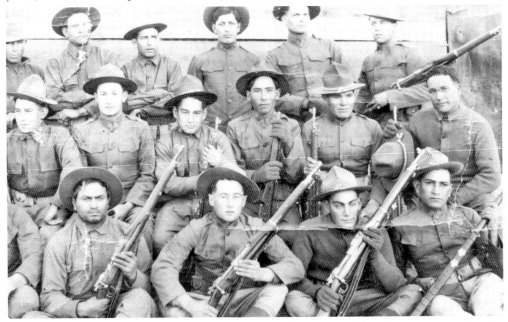

Charlie Pellon (second row, third from left) served in the National Guard as a company bugler. He played baseball in the border town of Nogales, Arizona, when Pancho Villa's soldiers were in attendance. Once, a colonel decided to umpire. When Charlie questioned a called at second base, the colonel pulled his gun, shot several times around Charlie's feet, and ran him off the field. Charlie was with the American Expeditionary Forces, 89th Division, 356th Infantry during World War I in France. (Courtesy of Darcy Quinlan Meyer.)

Raúl Félix played softball in the military while he was serving with the US Army at Ladd Air Force Base in Alaska. He is seen here at third base in a game between Signal Company (his team) and the 136th Ordinance. Raul's two brothers, Ignacio (who also played military ball) and Joe, were outstanding players in Claremont, California, playing during the 1940s and 1950s. (Courtesy of Rudy Gómez.)

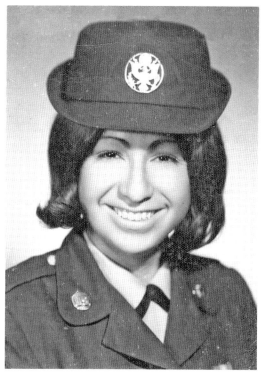

Irene Negrete was raised in San Fernando, California. Her father, Joe, was a Marine during World II. Her four brothers, Joseph, Leonard, Abel, and Arthur, served in the military. Irene's son, Adrian, served in Iraq. Irene joined the Woman's Army Corps in 1971, completing her basic training at Fort McClellan in Alabama. She was stationed at Oakland Army Base near San Francisco. She played on the softball team against women's teams, including Travis Air Force Base. She was stationed in Stuttgart, Germany, for three years. (Courtesy of Irene Negrete.)

WOMEN IN SOFTBALL AND BASEBALL

Mexican American women have a long, rich history in softball and baseball. The game allowed women to assert autonomy, cultural pride, and athleticism while maintaining their femininity. Sports tested socially constructed notions of femininity while slowing shifting traditional family structure. Teams emerged within school playgrounds, mutual-aid societies, religious organizations, community parks, and local businesses. Participation on the diamond mirrored social, cultural, political, and economic patterns across the nation.

In 1910, the Mexican Revolution pushed Mexican families into the United States. This shaped the composition of the nation's population, labor force, politics, and emerging communities. By 1915, efforts commenced to Americanize Mexican immigrants. The focus became women and children. Social reformers employed softball and baseball as a tool for Americanization. Nevertheless, sports elevated community and cultural pride, evident through teams' bilingual names and recognition of barrios, as well as neighborhood cooperative spirit.

By the 1930s, the Great Depression hit America with vengeance. Sadly, minorities bore the brunt of the economic frustration. The government enacted the Repatriation Act, which removed an estimated one million people of Mexican descent. In the 1940s, de facto segregation limited access to jobs, public amenities, housing, schools, movie theaters, and cemeteries. Despite racial segregation, Mexicans American led unions and communities flourished, sponsoring various softball and baseball teams.

As males enlisted in the service, it left a void on and off the field. Consequently, World War II cultivated more women's softball teams. A shortage of employees in the defense manufacturing industry pushed women into these jobs, which offered higher pay. Between 1943 and 1954, the All-American Girls Professional Baseball League (AAGPBL) recruited women to join its league, 11 of them Latinas. It replaced several minor-league teams disbanded due to the war. In 1972, Title IX broke down barriers in women's sports, opening doors to collegiate sports and scholarships. Overall, this chapter plays tribute to the courageous women who served as pioneers in softball and baseball, paving the way for future generations.

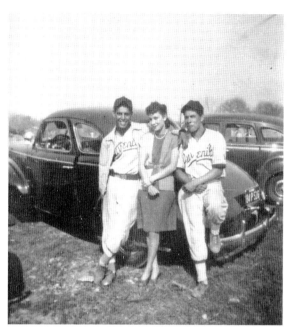

Stella Ayala Encinas stands side-by-side with two players from the Juvenile baseball team of Claremont. She played for the Questionettes of Chino. She later married Maury Encinas and raised the next generation of female players. Her brother, Congressman Ruben Ayala, represented the western San Bernardino County cities of Chino, Colton, Fontana, Ontario, and Rialto, and Pomona in Los Angeles County. He became the first elected mayor of Chino and served the California State Senate from 1974 to 1998. (Courtesy of the Encinas family.)

Stella and Maury Encinas, with other spectators, sit and watch a Juveniles game. Restricted from participating on whites-only teams as well as playing on official park grounds, Mexican American players established their own teams and venues. Discriminatory practices pressed teams to play in vacant lots and empty fields. In some cases, those who owned vehicles surrounded the makeshift diamonds, creating bleachers. Teams, family members, and communities rallied together to fundraise for equipment and uniforms. (Courtesy of the Encinas family.)

The Questionettes of Chino played in the Pomona Valley Women's Softball League and became the undefeated champion team. They remained unbeatable during a six-game series. Art Wagner, chief of the Chino Fire Department, managed the all-girls team. The team included members such as Lila Kinzey, Stella Ayala, Mary Jane Robles, Margaret English, Frances Dipoli, Betty Dixon, Harriet Decker, Jean Groomes, Elaine Maxey, Tommy Kulpenski, Peggy Webster, and Emma Boyen. (Courtesy of the Encinas family.)

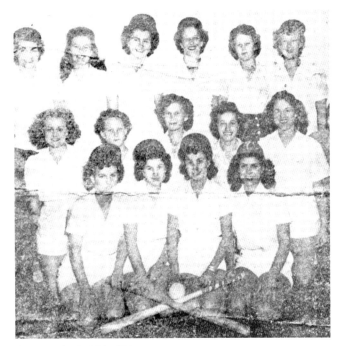

From 1964 to 1967, Stella Briones participated in women's fast-pitch softball in Chino, California. Her father, Amado, coached her and the team. As migrant farm workers, the Briones family traveled throughout the Southwest following the harvest. By 1924, the family settled in Southern California. For some migrant workers, sports functioned as a unifying factor when employed in company towns, farms, and packinghouses. The patriarch of the family, Amado passed down the love for the sport to future generations. (Courtesy of Chuck Briones.)

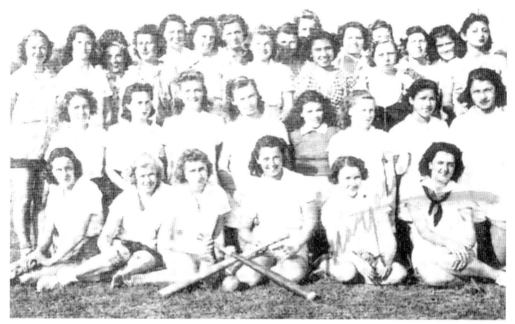

In the 1930s, Virginia García Elías played softball for the Girls' Athletic Association (GAA) at Valencia High School in Placentia, California. Founded in 1922, the organization spread throughout the United States recognizing female athleticism. It sought to promote healthy recreations while opening athletic fields and gymnasiums for females. The various sports of interest included baseball, basketball, bowling, hiking, horseback riding, swimming, and tennis. Virginia, along with Pedro, her husband, passed the love for the sport to their children. (Courtesy of Estella Elías Acosta.)

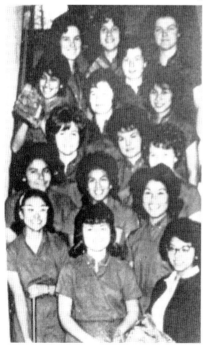

Growing up in Pomona during the 1950s, Estella Elías Acosta and younger sister, Lydia Elías Mulkey, enjoyed playing ball with local youth. The neighborhood youth shared equipment such as bats, balls, and gloves. They played on an improvised field adjacent to the Elías home that their father, Pedro, kept up. Although the games were informal, they became instrumental in the development of their softball skills and sportsmanship. In 1962, the Elías sisters participated on the Pomona Catholic High softball team. (Courtesy of Estella Elías Acosta.)

In 1963, Estella Elías Acosta attended Cal Poly Pomona, only two years after the first women were admitted into the institution. She earned recognition in softball with a certificate. She, along the other team members, set the foundation for official women's sports teams at Cal Poly Pomona, which grew in the 1970s. This shift emerged with the passing of Title IX, which protected against discrimination based on sex for education programs and activities that received federal financial assistance. (Courtesy of Estella Elías Acosta.)

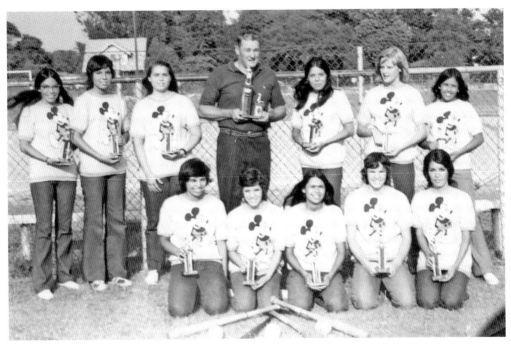

The 1960s Chino-based softball team was comprised largely of family members, a common practice among teams. Represented are, from left to right, (first row) Patty Encinas, Marlyne Encinas, Valentina Ruiz, Debbie Allen, and Patti Encinas; (second row) Nancy Encinas, Jernell Encinas, Darlene Allen, Dale Peevey (manager), Bonnie Encinas, Peggy Peevey, and Margaret Padilla. In the 1970s, many of the girls also played for the Van Dyk's Mod-Maids of Chino, winning 13 of 15 games and earning a championship. (Courtesy of Patricia Encinas García.)

Betty Hermosillo Reynoso pitched for the Claremont Panthers. She was an awesome fastball pitcher. Lola Hermosillo, Vivian Aguilera, Virginia Hermosillo, Luz Guerrero, Lupe Guerrero, Isabela Martínez, and Mary Gutiérrez made the team. The team represented the tenacious spirit of Mexican Americans, relegated to the outskirts of town in barrios such as Árbol Verde that bordered the cities of Montclair and Upland. These enclaves promoted culture pride and community sustenance through sports, patriotic celebrations, and religious events, as well as dances. (Courtesy of Ronnie Reynoso.)

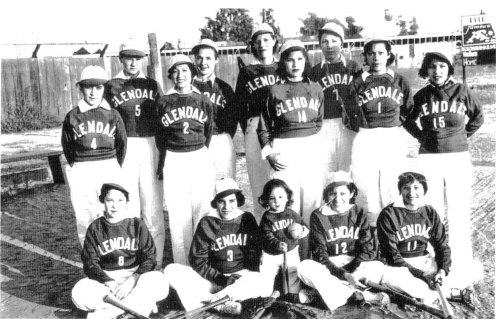

The Señoritas of Glendale traveled throughout the Los Angeles area playing against teams of different ethnic backgrounds. They competed with teams such the Masquerettes and George Von Elm's Birdies. The *Los Angeles Times* highlighted the team on April 28, 1936, with a caption that reads, "Snappy Spanish Señoritas Play Pelota Muy Buena." The team displayed its talents at the 1936 championship for the American Softball Association at Loyola Stadium in Los Angeles. (Courtesy of Vincent Pérez.)

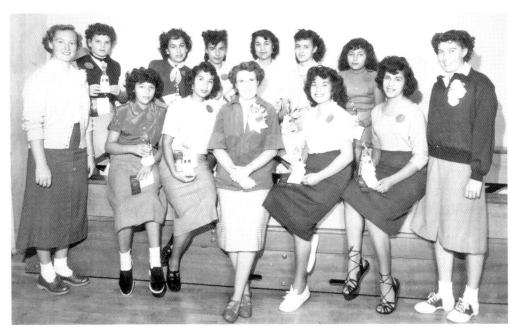

The 1951 champions of Belvedere Park in East Los Angeles, the Colombians, played against the Rosewood Park Royalties, Bell Garden County Park Parkettes, and Laguna Cupids. Trophies went to captain Lupe Díaz, Alma Galindo, Carmen Carrillo, Cherie Payne, Lucy Amparano, Ophelia Carrillo, Margaret Castañón, Natalie Amparano, Rose Marie Rice, Sally González, and Stella Sánchez. The street attire and hairdos suggest the effort to maintain a feminine presence, despite their athletic talent. (Courtesy of Alma Gallindo.)

Della (left) and her sister Anita Salazar are in front of Bridges Auditorium at Pomona College in 1943. Both sisters along with a third sister, Connie, played for the Claremont Braves, a Mexican American women's softball team, from 1943 through 1946. Connie and Della pitched, while Anita played third base. They played against other Mexican American women's teams from Pomona, La Verne, San Dimas, and another team from Claremont. The coach for the Braves was Joe "Chino" Torrez, an outstanding player in the Pomona Valley. (Courtesy of Anita Salazar Elias.)

Connie Salazar pitched for the Claremont Braves along with her sister Della. Other players were their sister Anita, Lola Contreras, Cruz Moreno, Rosa Melendres, Helen and Mary Parilla, Rosa Torres, Gloria Gonzales, and Mary Aceves. The Salazar sisters had several brothers who served in the military, including three who fought in World War II: Ruben, Manuel, and Ausencion. Ausencion, also known as Chone, was killed in the Pacific. It is believed he died on the island of Cebu. (Courtesy of Anita Salazar Elias.)

Dorothy Romero of the Rock-Ettes poses amid an open field. Growing up in the 1940s, her family lived on a farm on Nance Road in Santa Barbara. The region possessed a wide array of ethnic groups, including Filipinos, Italians, Japanese, Mexicans, Portuguese, and Swiss. The Rock-Ettes reflected the diversity. The area's rich farmlands produced jobs on the field and in packinghouses. For many teams, Sunday became game day. Her team dominated the league and earned a championship in 1945. The Guadalupe Rotary Club sponsored the team. (Courtesy of Dorothy Romero Oliveria.)

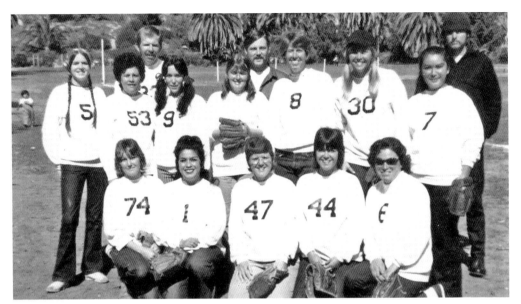

The Catalina Island Firebells played during the early 1970s. The Los Angeles County Fire Station 55 sponsored the team, hence the team name. A number of Mexican Americans played on the team, including Maui Saucedo Hernández (no. 53), Vickie Hernández (no. 9), Stella Hernández Herrington (no. 7), Gayle Saldaña (second row, fourth from left), Rose Hernández Engel (no. 1), and Cookie Saldaña (no. 6). Anglo teams often invited Mexican American women to join the teams because of their incredible talent and teamwork. (Courtesy of Theresa McDowell.)

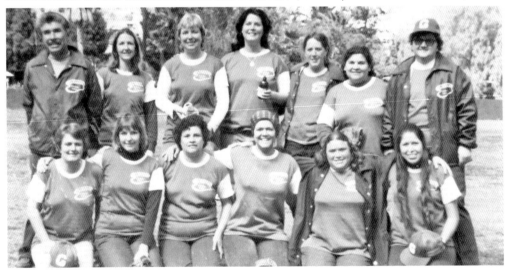

In the early 1970s, a local restaurant sponsored the team El Galleon. The team was comprised of a mixture of women including pitcher Chatta Saldaña Ponce, whose father worked for the Wrigleys as a gardener. Maria Hernández Soto, who also played, was the daughter of Lipe and Maui Hernández, players themselves; she effectively blocked the plate, knocking people down. Many of the women grew up on Tremont Street, one of four Mexican barrios on Catalina Island. (Courtesy of Theresa McDowell.)

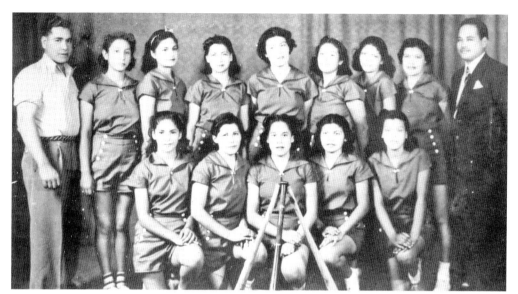

On August 18, 1940, the *Sacramento Union* highlighted six teams from the Second Division Girls' Municipal Softball League. Mexican American women made up the Rio Grande softball team. The division included teams such as the Woolworths, Garlicks, Telephone Company, and Pioneer Venetian Blinds. Team members included manager Buzz Dávila, Linda Sánchez, Jennie Dávila, Mary Dávila, Muzzie Valenzuela, Teresa Rojas, Josephine "Josie" Rojas, Babe Cervantes, Lily López, Margret Rojas, Adeline Huerta, Chelo Sánchez, and García Carrillo. (Courtesy of the Cervantes family.)

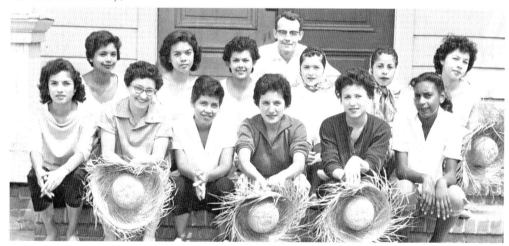

Rachel Cervantes-Wallin (second row, third from left) played for the Catholic Youth Organization team in Sacramento around 1956. She played basketball, softball, and volleyball for St. Joseph Grammar School and Bishop Armstrong High School. At the age of 12, she played for the Sacramento's Women's Nite Softball League. At Sacramento City College, Rachel played basketball, softball, field hockey, and was the top player on the tennis team. She has coached several sports for years. She was a teacher, counselor, and a principal in the Sacramento Unified School District. (Courtesy of Rachel Cervantes-Wallin.)

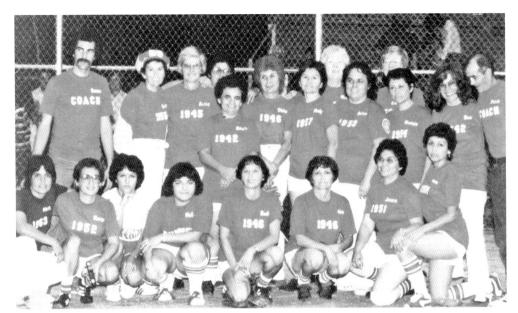

Arizona Hall of Famer Grace Pellón started to play softball as a preteen. Her father, Charlie, played ball himself. She played on various teams during her lengthy softball career. She passed on the love for the sport to her children and grandchildren. Her daughter, Norma Gallegos, earned a scholarship to play softball at the University of Arizona in Tucson. She made history as part of the 1974 team, Arizona's first Women's College World Series team. (Courtesy of Darcy Quinlan Meyer.)

In 1947, three thousand spectators showed up to raise funds for Joaquin Carranza, a boy who lost his legs in a train accident in Tucson, Arizona. The All-Stars, an all-girls team managed by Grace Pellón, played Charlie Pellón's Old Stars, men over 45 from Southern Pacific Railroad. The bout took place at Twenty-second Street Park, tickets sold for 25¢, and the umpire dressed like a clown. The All-Stars won the game, 27-14. The Coció-Estrada American Legion Post turned over all proceeds to his family. (Courtesy of Darcy Quinlan Meyer.)

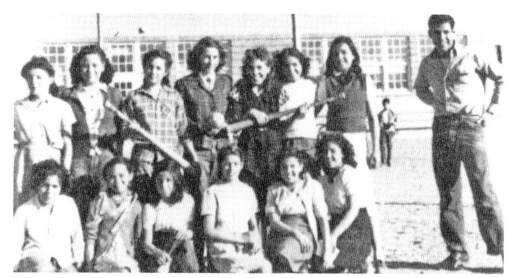

In the 1880s, Barelas, New Mexico, began to change as the Atchison, Topeka & Santa Fe Railroad ran though the mid–Rio Grande Valley. This reshaped the landscape and disrupted the agricultural economy. However, sports remained constant, serving as an avenue for social and family events. Baseball coach Vince Aragón worked with neighborhood youngsters for nearly 50 years. The 1940s girls baseball team outside on the school playground is a good example. (Courtesy of the National Hispanic Cultural Center.)

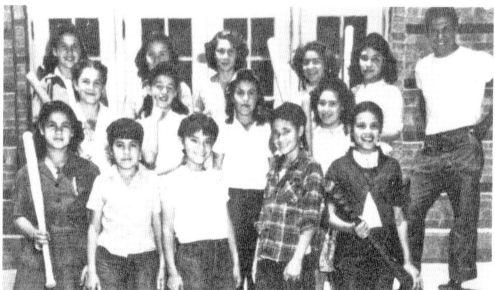

This young all-girls softball team from New Mexico displays their bats and street attire on the steps of the school grounds. Sports at an early age prompted the development of character among youngsters while encouraging community involvement and pride among adults. Girls in sports needed to balance traditional ideals of a proper young woman and athletic talent. These ideals presented themselves in team names, uniforms, and kinships with teams, as well as sponsors. (Courtesy of the National Hispanic Cultural Center.)

In the 1950s, the San Antonio Angels baseball team was sponsored by the Owl Bar and Café in Socorro County, New Mexico. Members shown included, from left to right, (first row) Mabel Ramírez, Isabel Montoya, Rowena Eaton Baca, and Celia Martines; (second row) Flora Chávez, Dee Chávez (coach), and Rosa Lucero; (third row) Lupe Montoya, Christy Chávez, Petra Rivera, and Josie Padilla. The team practiced consistently, playing teams nearby and as far as 50 miles. (Courtesy of Rowena Baca.)

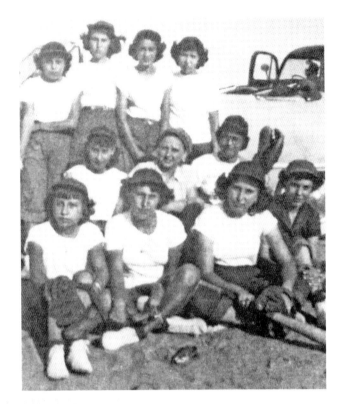

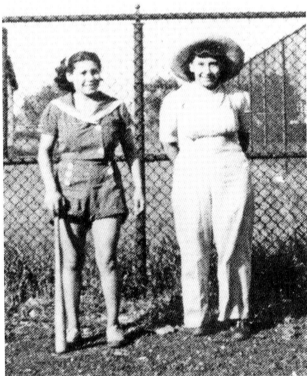

Las Gallinas often traveled with men's teams, particularly Los Gallos (the Roosters) of East Chicago, Indiana. Some games became double-headers; the women played in the morning and the men game played later in the day. Players Alice (left) and Bertha Zaragoza displayed their talents on the field. Some of the female players were talented enough to play side-by-side with their male counterparts. Parents supported their daughters, but often brothers and other family members watched over them during practice and games. (Courtesy of Señoras of Yesteryear.)

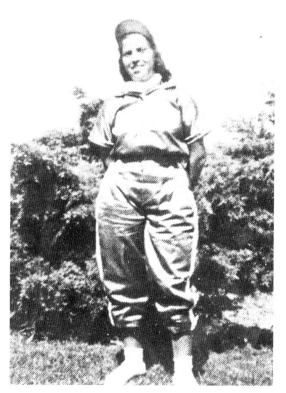

In the 1930s, women's softball teams sprouted throughout the Midwest. Mexican American women were no different; Pitcher Petra González Segovia of Las Gallinas (the Hens) of East Chicago, Indiana, is a prime example. The team, greatly supported by the community, took collections from their enthusiastic fans to purchase new green satin uniforms, which they proudly wore during games. Men mostly coached and managed the women's teams. These men proudly become involved and were respected by parents as well as the community. (Courtesy of Señoras of Yesteryear.)

Florence V. Porras and other members of Las Gallinas became community attractions. The team's popularity prompted organizers to begin a junior team called Las Gallinas Chicks. During World War II, the dynamics of women's role in society changed. As men enlisted in the service, defense manufacturing plants called on women to fill the labor shortage, giving rise to the iconic "Rosie the Riveter." Their younger sisters would play for the 1949 girls softball team led by the Young Christian Workers (YCW). (Courtesy of Señoras of Yesteryear.)

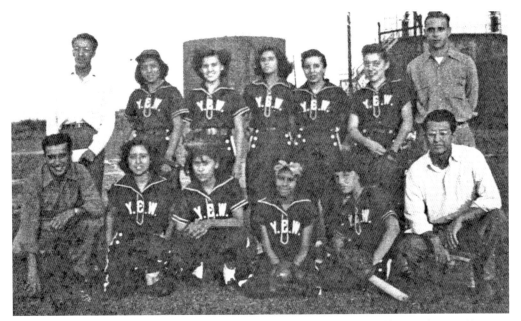

The 1949 girls softball team of East Chicago included, from left to right, (first row) Louis Vásquez, Minnie Patino, Carmen Torres, Alice Vásquez, Patsy Godoy, and Frank Villarreal; (second row) Stanley Ríos, Cecilia Buitron, Eleanor Vásquez, Mary Torres, Sally Bedoy, Alice Patino, and Charley Ursa. Their best and youngest player, Cecilia Buitron, helped the team to many wins. The team played behind Field School, behind the Wallace coal yard, or at an empty lot on Guthrie Street along the Pennsylvania tracks. (Courtesy of Lupe Aguirre.)

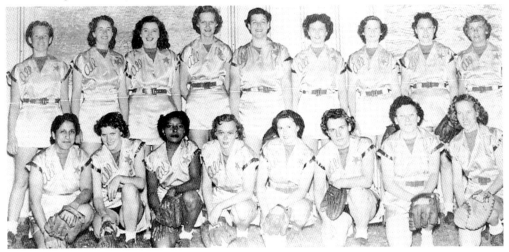

The Quad-City Girls All-Star Team of 1950 played at Douglas Park in Rock Island, Illinois. The team was comprised of elite softball players from the Eagles, Glicks, Servus Rubber, and Pepsi. The team featured Margaret Macias (first row, first from the left) from the Eagle's Market Superettes. The year prior, she and her sister, Juanita Mary Conchola, a member of the Women Army Corps at Randolph Air Force Base, played in the National Softball Congress World Championships, hosted in Colorado. (Courtesy of Dar Hanssen.)

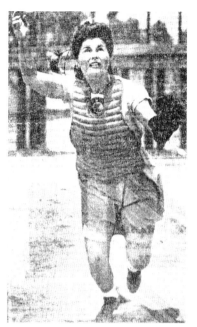

Margaret Villa Cryan of the Kenosha Comets was one of 11 Latinas that played for the All-American Girls Professional Baseball League (AAGPBL). Philip W. Wrigley, owner of the Chicago Cubs and the famed chewing gum, created the league, which began in 1943 and disbanded in 1954. Margaret played for the team from 1946 to 1950, playing second base and shortstop but mainly catcher. The league hit its peak in 1948. Teams formed in Midwestern cities, where there was a lack of major-league teams. (Courtesy of Margaret Villa Cryan.)

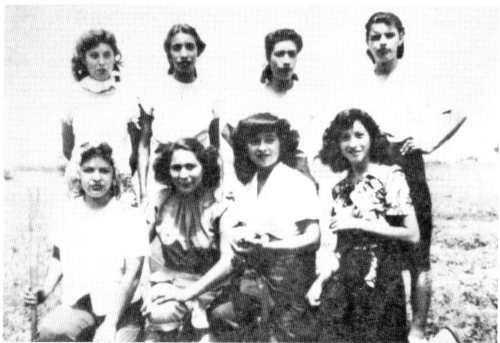

The North End Wichita girls' teams of the 1940s reflect the growing popularity of softball in the Midwest among Mexican Americans. Pictured from left to right are (first row) Cora ?, Victoria Díaz, Carmen Alfaro, and Maggie Gallardo; (second row) Alice Gallardo, Marcella Díaz, Eva Díaz, and Yolanda Castro. Family members often played together; it served as an indirect chaperone system. During dates, dances, and social events, parents utilized chaperones in order to monitor their daughters' moral behavior. (Courtesy of Ray Olais.)

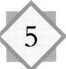

THE GOLDEN STATE

Baseball played major roles in the lives of Mexican Americans in California. This was especially true among young people. Years ago, due to racial discrimination and prejudice, Mexican Americans were not permitted to play in city leagues nor other forms of organized ball. Often, they were discouraged from trying out for school sports. Society had defined them as social outcasts. As a response to this social isolation, Mexican Americans in California developed divergent strategies and organized groups to combat social inequality and, equally important, to preserve their rich heritage. These communities firmly incorporated sports to promote collective identity, community autonomy, and reaffirm power symbols of *La Patria*.

Mexican Americans were devoid of pity, bitterness, and vengeance, despite heart-wrenching and sometimes painful and tearful experiences. They simply could not take life for granted. Instead, they taught their children the profound appreciation of hard work, religion, family ties, cultural pride, and community achievement. Perseverance is the cornerstone of Mexican American history in California. Mexican American leaders, parents, and civil rights groups understood that team sports for the youth, especially baseball and softball, were political tools to teach their children the traits of community solidarity, cultural affirmation, fair play, competition, leadership, overcoming adversity, and team work.

That is why mutual aid societies, the League of United Latin American Citizens, the American GI Forum, and labor unions supported youth teams: because it was part of a greater agenda to internalize these political skills through recreation. Mexican Americans pushed the Catholic Church to support sports for their children. The Catholic Youth Organization (CYO), mission leagues, and the Catholic Leagues, among others, promoted teams almost always named Las Guadalupanas. Moreover, parents formed youth teams named the Aztecas, Mayans, Indios, and Cinco de Mayo as a means for their children to pay tribute to their rich heritage, especially their indigenous bloodlines. The Fiestas Patrias deliberately included baseball games as part of the cultural program.

Mexican American youth were playing baseball in Los Angeles in the 1870s and everywhere by the early 1900s. Today, Mexican American youth still love playing ball for their parents and community, the same reasons as 145 years ago.

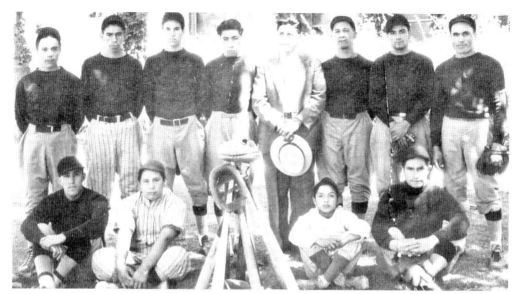

This 1930s Mexican American team photograph was taken at Oakdale High School near Modesto. Except for the batboy, all of the team members later served in World War II. Like many teams during this era, there are sets of brothers. From left to right are (first row) Eckee Hernández, Abraham Carrillo, and two unidentified; (second row) Manuel Carrillo, Albert Alfaro, Floretino Navarro, ? Francisco, Venturo Hernández, Ray Monges, Trinidad Terado, and unidentified. (Courtesy of Cecelia Estrada.)

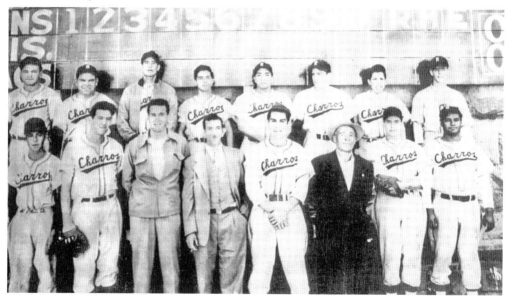

Several Mexican American teams throughout California played correctional teams on a weekly basis. This Riverbank-Modesto Charros team is seen at Folsom Prison in the 1940s. From left to right are (first row) N. Carlo, S. Jiménez, unidentified (the Folsom athletic director), Pete Estrada, Joe Estrada, A. García, O. Sandoval, and C. García; (second row) F. Jiménez, Art ?, unidentified, J. Ulloa, L. Alonzo, L. Alfaro, D. Vallo, and T. Herriage. (Courtesy of Cecelia Estrada.)

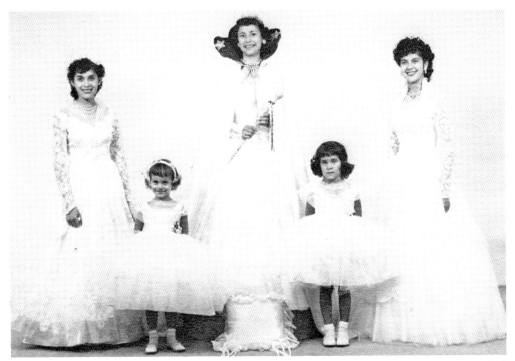

Cipriano and Pascuala Díaz settled in Turlock, California, from Mexico, where Cipriano worked at a slaughterhouse. Besides raising six children, Pascuala cooked for Mexican Braceros working in Ballico, California. Their three boys played baseball and excelled in other sports at Turlock High School. Both Tony and Jess served in the military. Their sister, Elvera, is shown here in Modesto as the September 16th Mexican Independence queen in 1953. She was serenaded in Turlock by the great Mexican singer Miguel Aceves Mejia. (Courtesy of Elvera Díaz Jiménez.)

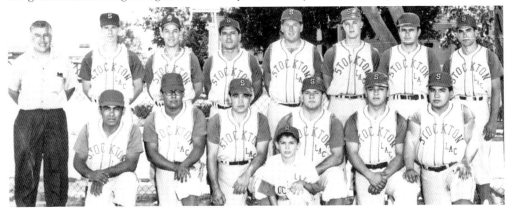

The Stockton Latin American Club played in the Cal-Mex League for over 10 years. They played other teams from Stockton, Tracy, and Woodland. This photograph was taken in 1960 at Stribley Park. The batboy is unidentified. From left to right are (first row) Al Moreno, Joe Aguilar, Joey Cortez, Bob Gererro, John Moreno, and Carl Abulis; (second row) coach Bruno Cardona, Bill Catlett, Benny Gererro, Hank Moreno, Dave Zellmore, Ronnie Kuehl, Frank Garcia, and Paul Devenchenzi. (Courtesy of John Ward and Roy P. Alvarez.)

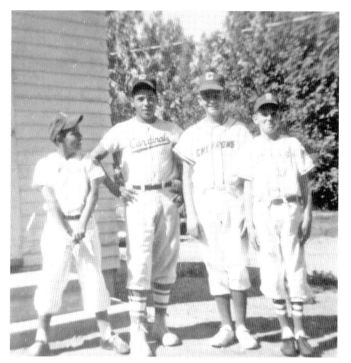

David Trujillo (far left) played baseball in Fresno, California, during most of the 1960s. David remembers the hot summer months and watching night baseball at Calwa Park. Later, he played at Holmes Recreational Center and Romain Park. He played shortstop in Little League, Babe Ruth baseball, pickup games, street games, and schoolyard ball. David has been active with the Chicano movement and, for the past 27 years, has served as a union representative for highly skilled professionals. (Courtesy of David Trujillo.)

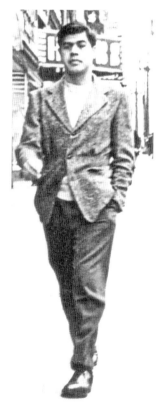

Ray Ortez pitched for three Central California leagues: the Porterville Reds and Lindsey Packers of the San Joaquin Valley Nightball League in 1940; the Richfield Oilers and Taft Elks of the Kern County Industrial Leagues in 1940 and 1941; and with the Taft Elks in the Taft Softball League in 1942. Ray also played with the Visalia Night Hawks. Due to World War II, many of these teams and leagues disappeared. Ray returned to Anaheim, pitching for the Santa Ana American Legion team in 1947. (Courtesy of Monica Ortez.)

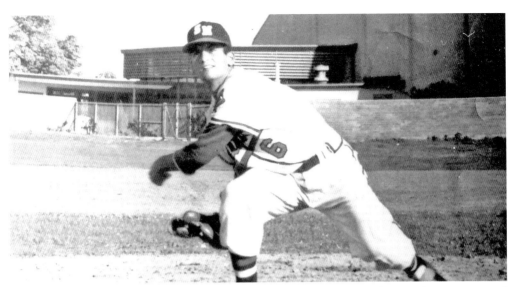

Ray Torres played Little League baseball in the mid-1950s for the Elks and Union Sugar–sponsored teams, making the all-star teams in Santa Maria. Ray played Middle League ball for the Police Boys, coached by Jim Cobb, whose father was the legendary Ty Cobb. Ray played four years of high school ball and eventually played for the Los Alamos Cowboys of the Santa Maria Valley league. He retired in 2003 after 29 years in education, including 17 years as principal. (Courtesy of Ray Torres.)

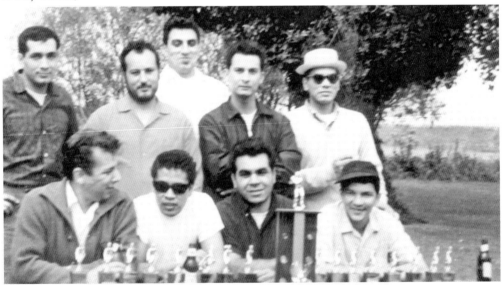

Starting in the 1930s, games were played at the Guadalupe field. This land had been donated by a Japanese farmer, Setsu Aritani, who loved baseball. The field was the first to have lights in the region. The Guadalupe Little League started in 1952. The Falcon softball team is seen here at an awards event. From left to right are (first row) Robert Rivas, Victor Cabatuan, Joe Talaugon, and Teddy Rainis; (second row) Ray Antunez, Frank Ramos, John Alvarado, Tommy Reyes, and Herman De La Cruz. (Courtesy of Joe Talaugon.)

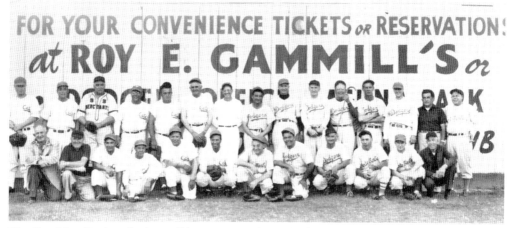

The Brooklyn Dodgers had an affiliate team in Santa Barbara in the 1940s. Dodger players and coaches gathered with local semipro ball players. There are at least two Mexican Americans: Pete Sánchez (first row, third from right) was a left-handed pitcher, while his catcher, Joe Granada Sr., is wearing a Santa Barbara Merchants jersey (second row, third from left). The battery of Sánchez and Granada was a mainstay of Mexican American teams from the 1930s to the 1950s in Santa Barbara County. (Courtesy of Richard Sánchez.)

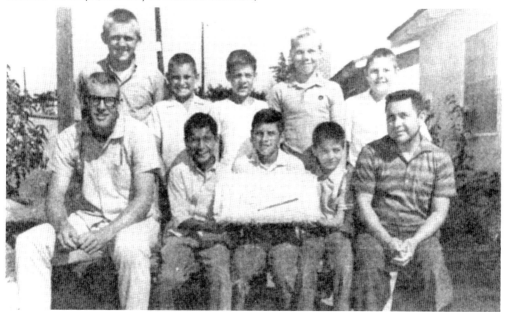

In 1961, the Carpinteria Red Sox claimed the American League title in the Summer Recreation Program. Dr. Jim Campos, longtime educator and local historian, played alongside his little brother, Arthur. Of course, 1961 was the year that Roger Maris hit 61 home runs, breaking Babe Ruth's record. From left to right are (first row) coach Jon Washington, Gilbert Méndez, Joe Escareño Jr., Arthur Campos, and coach Joe Escareño; (second row) Mike Donnelly, Joe Lovett, Jim Campos, Fred Pilkey, and Ricky Gesswein. (Courtesy of Joe Escareño Jr.)

During his younger days, Nicanor S. Cortinas played semiprofessional baseball in the San Joaquin Valley in the 1930s. It was a league where one town played another town on Sundays. At the time, he lived in Arvin, California, playing against Mexican American teams from Wasco, Delano, Shafter, McFarland, Oildale, and Lamont. Pictured in 1936, he is holding his son Ángel, who picked up the love of the game from his father. Ángel grew up playing baseball in the North Hollywood area. (Courtesy of Ángel Cortinas.)

Ángel Cortinas and his younger brother, Martín, are standing in front of their Sun Valley home. Ángel played American Legion baseball in 1951, third base for the Disabled Veterans (DAV) team, and at Los Angeles Valley College in 1953–1954. Martín was the DAV batboy and followed in his brother's and father's baseball footsteps by playing on the Sun Valley Little League in 1951–1952, North Hollywood High School from 1956 to 1958, and with Pierce College located in Woodland Hills in 1959–1960. (Courtesy of Martín Cortinas.)

Jesús Miranda (first row, left) was a bilingual musician and singer. He played at the best nightclubs on Catalina Island and in Las Vegas. He joined the US Army during World War II, serving in Europe. He played guitar in a band that entertained troops. He was especially popular among Mexican Americans servicemen, playing their favorite Mexican songs so far from home. He is seen here on a 1930s Los Angeles Mexican American team playing a game in Tombstone, Arizona. (Courtesy of Willie and Mary Ellen Miranda.)

Efrén A. Montijo (first row, second from left) was one of the first Mexican American sports stars in the Los Angeles region. He played four years of baseball at Occidental, including this 1917 team. His 1914 team placed second to USC Law School and ahead of Redlands, Whittier, Pomona, and Throop (later Caltech). The 1915 Occidental team placed first but lost in the championship game. Montijo was an outstanding pitcher all four years and was covered extensively by the *Los Angeles Times*. (Courtesy of Charlotte Montijo Sauter.)

Richard Peña was born in 1930 in East Los Angeles, California. His father, William, was an outstanding player during the first part of the 20th century. Richard is the youngest of the famous nine Peña baseball brothers coached by their father. He is shown here at 16 pitching for an American Legion team. He was an outstanding player at Roosevelt High School and played professionally in the United States and Mexico. He and his wife Gloria reside in Riverside, California. (Courtesy of Richard Peña.)

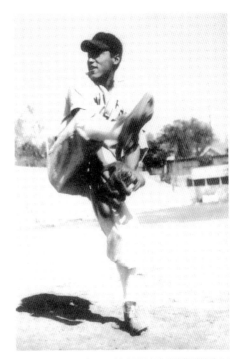

The Resurrection School team displays its Catholic Youth Organization (CYO) trophy for the 1961 championship season. Rivals included Assumption, Our Lady of Lourdes, St. Isabel, St. Mary, Our Lady of Guadalupe, Dolores Mission, and Our Lady of Talpa. Team members included Joe García, Domingo García, Ron Baca, Joe Gras, Robert Basso, Louie Yánez, Danny Díaz, Paul De La Rosa, Manuel De La Rosa, Jerry Bilderrain, Ramiro Sandoval, Joe Montelongo, Richard Ferralez, and Hector Cuecuecha. The Garcías and De La Rosas are not related. (Courtesy of Ron Baca.)

The players on this East Los Angeles team were raised in Ciudad Juárez in Mexico. They were from the barrio Parque La Chavena. As they migrated, they settled collectively in Boyle Heights. They formed a team named Parque La Chavena and joined the East Los Angeles City League in 1962. The players included F. Rodríguez, D. Silva, M. Rivera, C. González, M. Álvarez, C. Hermosillo, F. Bautista, O. Chacon, R. González, Q. Juárez, B. González, A. Rodríguez, and J. Lores. (Courtesy of Oscar Chacon.)

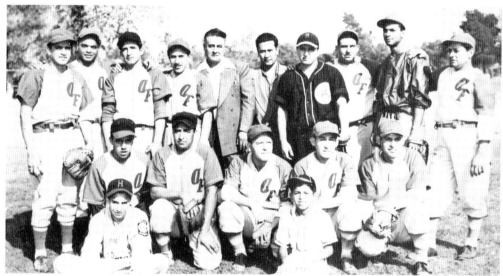

The American Freight Company sponsored this team after World War II. Many Mexican Americans took advantage of the GI Bill to learn a skilled trade. World War II had transformed the community from low-skilled and agriculture-related workers into industrial union jobs. Mexican Americans found work in the manufacturing sector, including packaging, transportation, and the production of crates to transport heavy machinery. On this team are brothers Milo (second row, far left) and Manuel Hernandez in the dark uniform. (Courtesy of Sergio Hernández.)

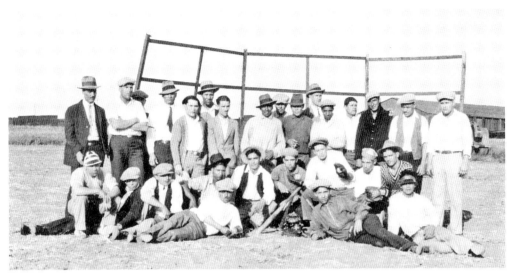

Tommy Pérez Sr. (second row, third from right) was a right-handed pitcher from Victorville-Barstow who threw a wicked knuckleball. Pérez also played in nearby Dagget and Yermo in the 1930s. Pérez had a successful baseball career in Los Angeles as well. He had been a close friend of Mario López when they played for Carta Blanca, a friendship so strong that Pérez managed both of López's businesses, Mario's Service Station and Carmelita Provision Company. His son, Tom Jr., became an outstanding player. (Courtesy of Tom Pérez Jr.)

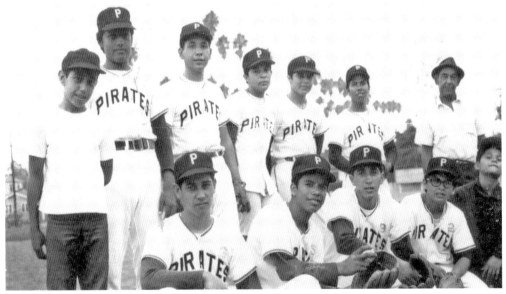

The 1969 Evergreen Pirates played at Evergreen Park in Boyle Heights. The manager was Jesús Paz, his coach was Al Reyes, and the two batboys were Randy Paz and John Saldivar. Jesse Estrada (second row, second from right) went on to coach at Evergreen Park when Jesús Paz retired. Jesse attended the University of California at Los Angeles (UCLA) and became a school police officer. He umpired and eventually trained umpires in Cooperstown. Sadly, he passed away in 2014. (Courtesy of Kevin Paz.)

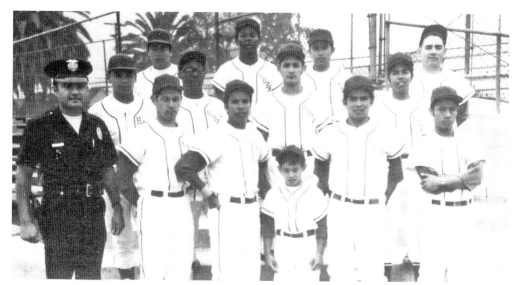

In 1969, the Los Angeles Police Department sponsored teams including the Hollenbeck Division in Boyle Heights. Jesse Estrada (second row, fourth from left) became a Los Angeles police officer. Pictured from left to right are (first row) Steve Paz, Mike Estrada, Kevin Paz, unidentified, and Al De La Rosa; (second row) Billy Téllez, James Roberts, Tony Lara, and Jesse Estrada; (third row) Jimmie Reza, Melvin Tinsley, Frank Ortiz, coach Jesús Paz, and officer Bob Acosta. Not shown is Victor Orona. (Courtesy of Al De La Rosa.)

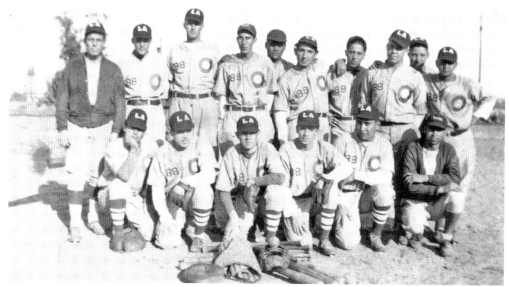

In 1932, the four Armenta brothers played for La Alianza Mexicana semiprofessional team in Los Angeles. Over their long careers in baseball, this was the only time they all played on the same team. Ray (first row, second from left) played over 40 years; Tony (first row, fourth from left) played a few years; Paul (second row, far left) fulfilled his passion for umpiring for 20 years throughout Los Angeles; and Oscar (second row, second from left) was the youngest brother. (Courtesy of Bea Armenta Dever.)

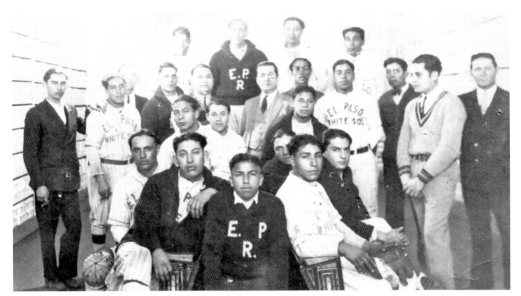

Ernesto Sierra was an outstanding ballplayer who spent his early baseball career in Arizona and Texas during the 1920s. His family moved to Los Angeles, where he continued to play baseball. His reputation as an outstanding pitcher landed him with one of the premier teams in Los Angeles, the El Paso White Sox. He is in the third row, third from left. The team was sponsored by the El Paso Shoe Store and was one of the best teams during the 1920s and 1930s. (Courtesy of Charlie Sierra.)

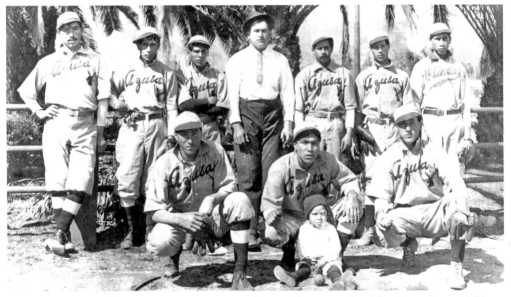

This photograph of the 1909 Azusa team was taken on the west side of the Azusa Santa Fe Train Station, From left to right are (first row) Arthur Cruz Trujillo; (second row) Frank "Chico" Cruz, Marcos Cruz, and Roger Dalton; (third row) two unidentified, Pedro Romero, team manager Mike, Richard "Richie" Ochoa, Raymond Macias Alva, and Frank "Chico" Mongels. This team was very well known throughout the San Gabriel Valley. (Courtesy of Jeffrey Lawrence Cornejo Jr.)

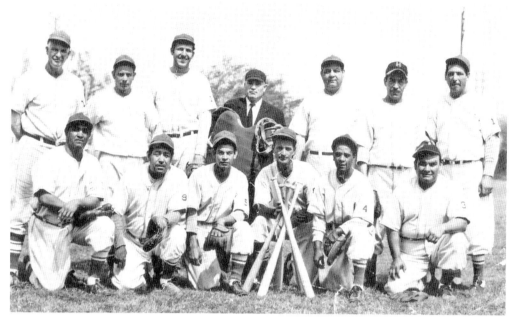

Frank Saiza (first row, third from left) was one of four brothers who played baseball in Los Angeles from the 1940s through the 1960s. During World War II, Frank was in the US Army, where he played military baseball. When the war ended, he returned to civilian life and played baseball with friends and cousins. (Courtesy of Rosemarie Olmos Esquivel.)

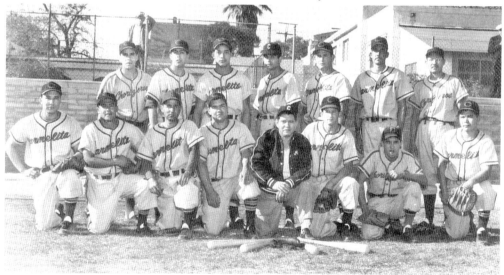

The Carmelita Provision Company teams during their heyday were known as the "Yankees of East Los Angeles" because they were often the champions. The company produced pork products, including its famous chorizo sausage. On this 1950s team are, from left to right, (first row) Freddie Yánez, unidentified, Ray Alderete, Johnnie Peña, manager "Shorty" Pérez, Chemino Magana, unidentified, and Yam Yánez; (second row) Richard Álvarez, Babe Órnelas, Joe Valenzuela, Joe Miranda, Larry Silva, and two unidentified. (Courtesy of Richard Peña.)

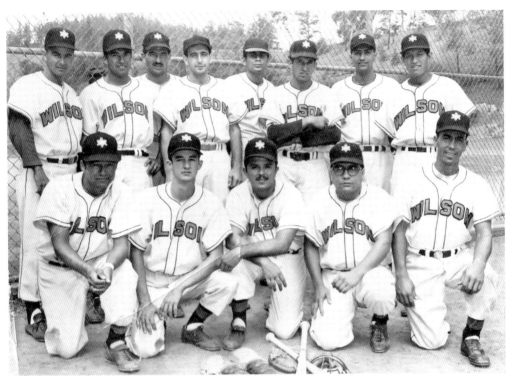

This photograph of the 1970 Wilson baseball team was taken at Hazard Park, located behind the General Hospital in East Los Angeles. Wilson Packers is the same Wilson Sporting Goods who made uniforms for the San Diego Padres. The uniforms in this image are pro quality. Some of the players on this team are Paul Falcon, Ralph Núñez, Mario Chávez, Lolo Chávez, and Jesse Reza. The manager is Dave Williams. (Courtesy of the Ralph Núñez family.)

This 1948 El Sereno Club played baseball in the Los Angeles Winter League. Players included Manuel López, Lefty Ortega, Alex Velásquez, Bobby Peña, Manuel Salcido, George Acuna, ? Herrera, Tom Echevarria, Trino Cervantes, Norbert Castel De Oro, and John Apodaca. Norbert (first row, far left) was the second of five children born to Sylvian and Louise Castel De Oro, who had migrated from Mexico. Norbert married Gloria Palanco in 1950. They had five children and five grandchildren. (Courtesy of Jaime Castel De Oro.)

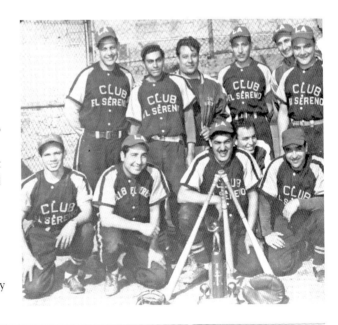

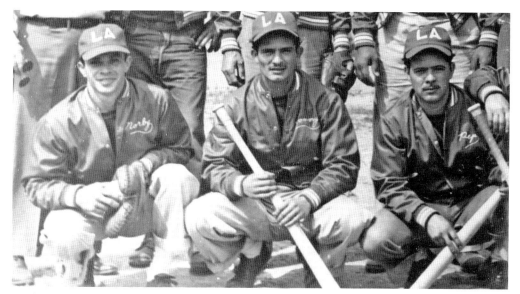

Norbert and Tommy Castel De Oro and their brother-in-law Joe López played ball for years in the Los Angeles region. Norbert (left) enlisted in the Navy in 1940 and later boxed as a professional fighter at the Olympic Auditorium and Hollywood Park. Tommy (center) enlisted in the Army during World War II, and he and his brother Norbert worked at the Los Angeles Produce Market all their lives. Tommy also boxed professionally. Joe also worked at the Produce Market and played infield. (Courtesy of Jaime Castel De Oro.)

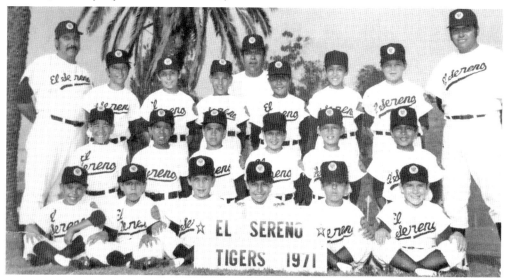

Anthony Luna was born in the El Sereno community of Los Angeles. As a youth, he played baseball and football. He played tennis in high school. His mother, Teresa, would take him and his friends to see the Dodgers play at Dodger Stadium. He attended Wilson High School and Pasadena Community College and graduated from California State University at Los Angeles. He is seen here (third row, third from right) with his 1971 El Sereno Tigers team. (Courtesy of Teresa Santillán.)

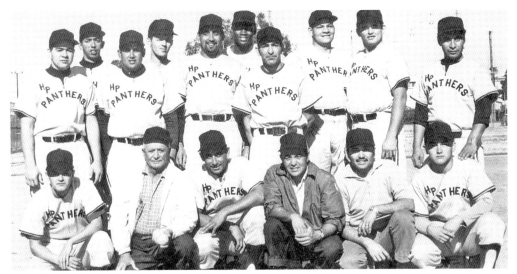

The Álvarez brothers were outstanding ballplayers in the South Central part of Los Angeles. The brothers are Richard, Rudy, Moises, Art, Remi, and Larry. Altogether, they played youth, high school, college, semiprofessional, and municipal city league ball, including three brothers who played in the military and three who signed professional contracts. The Álvarez players, along with the Saiza family (Joe Sr., Joe Jr., Tommy Paul, Lefty, George, and Johnny), established a baseball dynasty for years in South Los Angeles. (Courtesy of Remi Álvarez.)

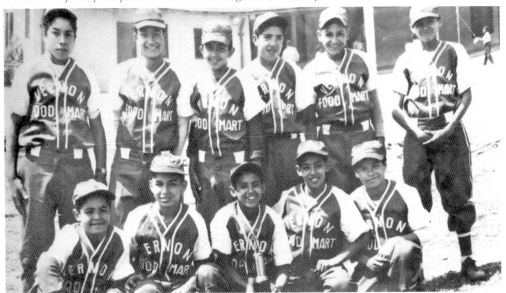

The Blue Devils started in 1946 as a Little League team in South Central Los Angeles. The team lost only two games in five years playing against older kids. From left to right are (first row) Gilbert Álvarez, Danny Ramos, Art Álvarez, Remi Álvarez, and Frankie Majaro; (second row) Manuel Bravo, Louie Majaro, David De La Cruz, Chito Álvarez, Tommy Saiza, and Lawrence Quiñónes. They played at Roosevelt Park in the Florence area. Their manager was Louis Álvarez, who provided transportation. (Courtesy of Remi Álvarez.)

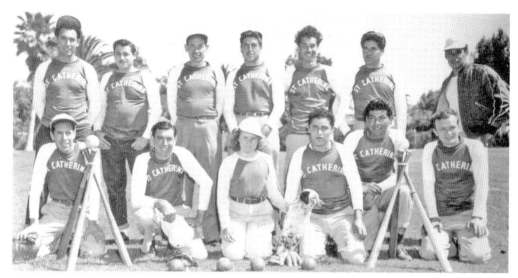

Mexican American teams and players have a long history on Catalina Island. They listened on radio to Pacific Coast League games, and the Chicago Cubs had their spring training facilities on the island. And like many communities, they formed a church team. The St. Catherine players are, from left to right, (first row) Johnny Reyes, Bill Flood, an unidentified bat girl, Martín Saldaña, Tony Hernández, and unidentified; (second row) Ray Machado, Wilfredo Herrera, Al Grilich, Joe Cervantes, Frank Machado, Vernon López, and Joe Machado. (Courtesy of Marcelino Saucedo.)

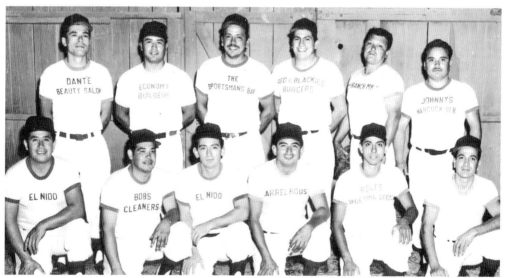

All of the Mexican American players on this 1961 team were raised in Wilmington, played many sports together since childhood, and now play golf as seniors. This team included three sets of brothers who won the Long Beach "A" Championship. From left to right are (first row) Art Hernández, Tony Rivas, Edward Mendoza, Gabby Mendoza, Elmer Fematt, and Rubén Aguirre; (second row) Dick Rivas, Dick Méndez, Jack Montgomery, Eugene Montgomery, Tony Manzo, and John Méndez. (Courtesy of Gabby Mendoza.)

6

Coast to Coast

The early 1900s witnessed an incredible demand for Mexican labor in the United States. Anti-immigration sentiment and legislation had blocked groups from entering the country from Asia and Eastern Europe. With the rapid expansion of several industries, including railroads, steel, agriculture, livestock, salt, oil, and hospitality, there were severe shortages of workers to fill these positions. There were competing forces at work. On one hand, companies wanted cheap labor from Mexico, while labor unions and anti-immigrant groups pushed back against Mexicans entering the country.

The Mexican Revolution of 1910, the entrance of the United States in World War I, and the postwar prosperity worked in favor of those who encouraged Mexican immigration. By the early 1920s, Mexican workers and communities could be found from California to New York, in the Midwest, the South, the Northwest, and the Southwest. There were, of course, older Mexican communities dating back before the Mexican-American War of 1846. There were literally hundreds of Mexican American communities during the 1920s. Most of these communities quickly established an elaborate network of associations and tactics to protect their political, economic, and cultural interests.

At first, a handful of Anglo charitable organizations and churches offered recreational facilities and sports to Mexican youth, including the YMCA. Nevertheless, the Mexican leadership chose to build its own sports clubs, recreational networks, and tournaments. These sports included baseball, softball, basketball, football, soccer, and boxing. In large cities, such as Los Angeles, San Antonio, Des Moines, Chicago, South Chicago, East Chicago, Detroit and Topeka, the Mexican community raised significant amounts of money to purchase land and build recreational centers that included basketball courts, weight rooms, baseball diamonds, boxing rings, basketball courts, and even swimming pools.

In many smaller communities, the residents constructed their own baseball fields in vacant lots or pastures near railroad tracks, roundhouses, steel mills, packinghouses, or beet fields. It was truly a collective effort as the location was cleared of rocks, debris, and the field leveled using discarded railroad ties. Women sewed the bases. These desolate lots literally became diamonds in the rough. Sunday was baseball day for Mexican American communities in the United States long ago and still is to this day.

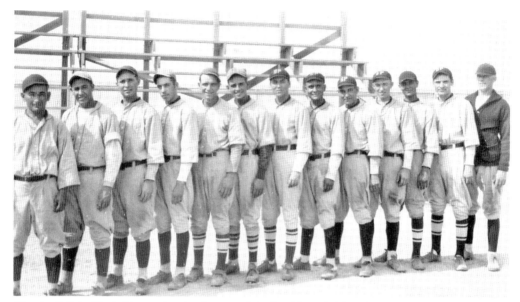

Charlie Pellón (far left) was the third son and forth of five children born to Pedro C. and Elena Mancera. His father migrated to the United States from Santander, Spain, through Mexico, where he met and married Elena. The family owned milk cows, and the Pellón children sold the milk in the neighborhood every morning. Charlie played and coached organized baseball throughout his life, including on Tucson's ragtag teams, military teams, Southern Pacific Railroad teams, and semipro teams. (Courtesy of Darcy Quinlan Meyer.)

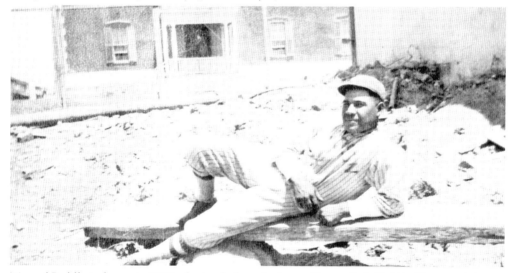

Manuel Padilla is shown in 1920 relaxing before playing at Groves Park Field in Tucson, Arizona. In those early years, not all ballparks had dressing rooms, so most players would arrive at the games already wearing their uniforms. His team played against teams from Southern Arizona, New Mexico, and El Paso. Although he was offered a professional contract, his father did not allow Manuel to sign because he was the family's primary wage earner during the Depression years. Baseball salaries were very meager. (Courtesy of Al Padilla.)

Ernesto Sierra was born in Clifton, Arizona, in 1898. Ernesto played for several teams in Arizona, Texas, and California. The mining companies, especially in the copper industry, recruited thousands of Mexicans and Mexican American workers to Arizona. Many of the segregated Mexican American communities established baseball teams. Ernesto is seen here in his Clifton baseball uniform around 1920 with a younger cousin. (Courtesy of Charlie Sierra.)

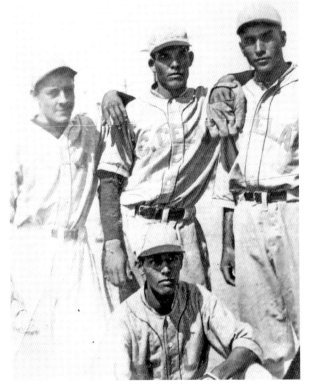

Ernesto Sierra was heavily recruited as a pitcher by other teams in Arizona. He is seen here (standing, center) with teammates on a Mexican American Phoenix team around 1925. The team traveled throughout Arizona and Texas. His father, Estanislado Sierra, moved his family of five from Arizona to Los Angeles. Ernesto continued playing baseball in Greater Los Angeles. Two of his sons, Charlie and Ernie, became baseball stars at Roosevelt High School in Boyle Heights, and both signed professional contracts. (Courtesy of Charlie Sierra.)

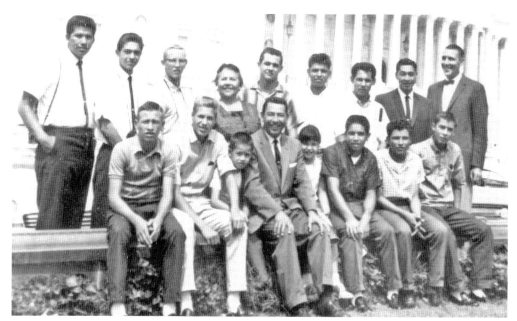

This 1961 Tucson All-Star team photograph was taken in Washington, DC. The team was comprised of players from six high schools and coached by Rudy Castro (seated, fourth from left.) They lost the championship game in Hershey, Pennsylvania, on a controversial call. The team visited Yankee Stadium and the Capitol with the help of Congressman Morris K. Udall (standing, far right). Also in this photograph are Castro's son Rudy Jr., mother Alicia Acedo Castro, and his daughter Linda seated next to him. (Courtesy of Linda Castro Spencer.)

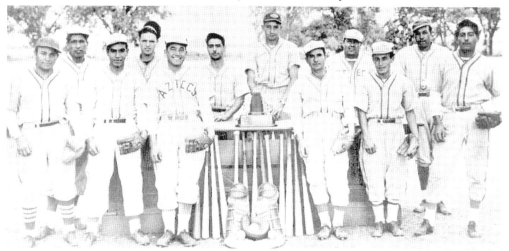

This 1940s photograph is of the Gilcrest, Colorado, Aztecas. Most were related and veterans of World War II and later Korea. From left to right are Rufus Peñaflor, Jack Chacon, Mike Soto, Manuel Balasan, Tony López, Alfred García, Harry Wize, Johnny López, Ray Chacon, Lino Peñaflor, Marcelino Romero, and Dave Peñaflor. Eventually, brothers Rufus, Lino, and Johnny Peñaflor (not shown) and Tony Villegas (not shown) moved to the small town of Nipomo, California, working in construction and playing Valley League baseball. (Courtesy of Tony Villegas.)

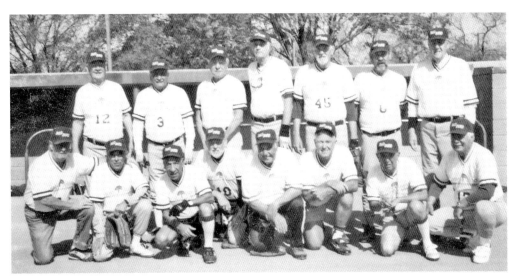

This 2004 senior team is from Albuquerque, New Mexico. Gil León (second row, third from left) would watch games and decided to try out for the team. His brothers Rey, Sam, and Joe are legendary players from the greater Pomona Valley region. Other players include Bill Castillo (first row, second from left), Al Chávez (first row, third from left), Max Vega (first row, fifth from left), Minder Valdez (first row, second from right) and Martín García (second row, second from left). (Courtesy of Gil León.)

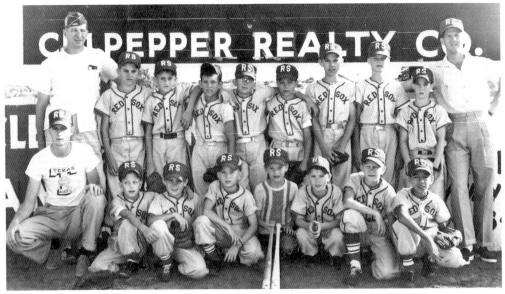

In the 1950s, Jack Fugate (standing left), Texas A&M graduate and decorated US Army World War II veteran, was a founding father of Little League baseball in College Station, Texas. Ambrosio Bernal, kneeling on the right side, was the son of a food service employee at Texas A&M and the first Mexican American to play in the program. Next to Ambrosio is Fugate's son, Jack, who excelled in college baseball for two years before enlisting in the Navy during the Vietnam War. (Courtesy of Sonny Benavidez.)

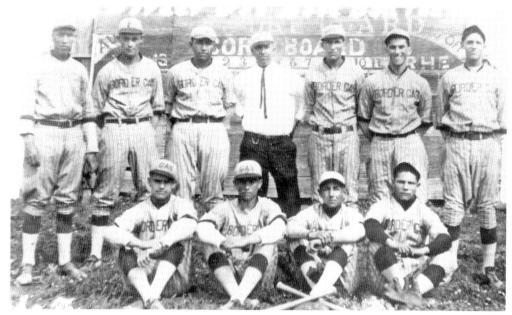

This is the 1926 Border Gas team from Laredo, Texas. John Ysidro Dickinson Jr. is seated second from left. Southwest Texas and Laredo were literally "baseball heaven" in the old days. And the foundation was Mexican Americans with last names like Dickinson, Leyendecker and Hein. Famous baseball family names also included Mejia, Azios, Bocanegra, Dovalina, Montalvo, Rodríguez, Contreras, and Santilles. Legendary Mexican players would barnstorm through the area including "El Malo" Torres, Ángel Castro, and Beto Ávila. (Courtesy of John Y. Dickinson III.)

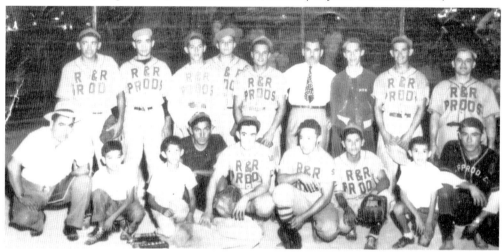

The Mexican community newspapers in Corpus Christi, Texas, rallied residents with news of city teams. Young men turned up at Longoria Park on Rabbit Run Road to try out for the team. Three of the best players on this 1947 R&R Products are Joe Medina Guajardo (second row, fifth from right), Andres Vasquez (second row, second from right), and Juan Sanchez (first row, third from right). Dan Bocanegra (first row, third from left) served as batboy. (Courtesy of Grace Guajardo Charles.)

The Western Division Dodge City, Kansas, Cowboys played in the Ban Johnson League in the 1950s. The Cowboys played their games at Wright Park near the Rodeo Grounds and the Arkansas River. Other Kansas teams in the league included Pratt, Liberal, Garden City, Larned, and Enid, Oklahoma. Most of the players were employed by the Santa Fe Railroad Company. Ray Martínez is third from left in the first row. The second row is, from left to right, Art Navarro, Pete Martínez, and Manuel Gonzáles. (Courtesy of Rod Martínez.)

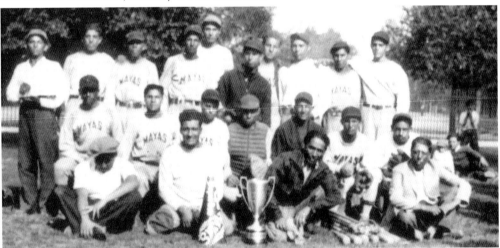

This is a group photograph of the 1930s championship team sponsored by the South Chicago Mayas Sports Club. Organized sports, especially baseball, provided a welcome respite from the daily grind during the Great Depression. Athletes proudly wore team jackets around the neighborhoods, and Spanish-language newspapers covered their games. Other South Chicago teams included the Yaquis, the Excelsiors, and Atlas. Youth teams included the Baltimore Aces and Buffalo Braves. Legendary players included Pete Martinez, Angel Soto, Gilbert Martinez, and Manuel Casas. (Courtesy of the Southeast Chicago Project.)

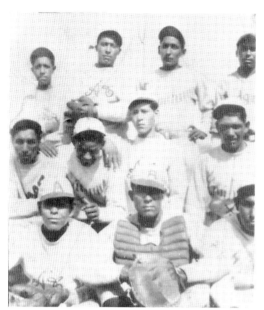

This 1933 Kansas team included brothers and cousins. Pictured from left to right are (first row) Eusebio Ortiz, Abundio Torres, and Juan Ortiz; (second row) Patricio Estrada, Frank Ortiz, Catarino Pautoja, and Rosalio Rosales; (third row) Frank Estrada, T. Guerrero, L. Ortiz, and José Villa. Patricio Estrada was born in 1906 in Jalisco, Mexico, and migrated to Colorado. He had 11 children with his first and second wives, Maria Placencio and Marcelina Guerra. He worked all his life on a farm and owned a small bank. (Courtesy of the Estrada family.)

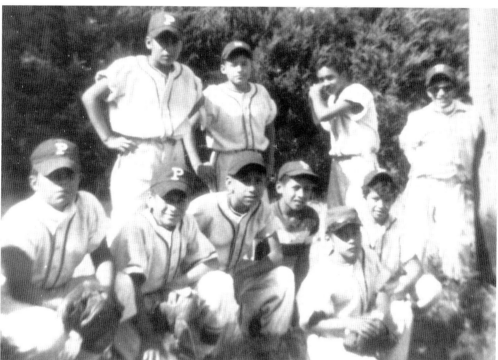

This 1951 photo is of the Newton, Kansas Knot Hole Pirates. They played their games at Tenth and Ash Park. John Arellano was the organizer of the team, and Fred Martínez was the coach. The Knot Hole League was integrated in 1952. There were still restaurants that did not serve Mexicans until the 1960s. Some of the players included Paul Vega, Marion Lujano, Louie Carrion, Freddy Martínez, Celio Sandate, Albert Arellano, Tino Monares, and Bobby Jaso. (Courtesy of Paul Vega.)

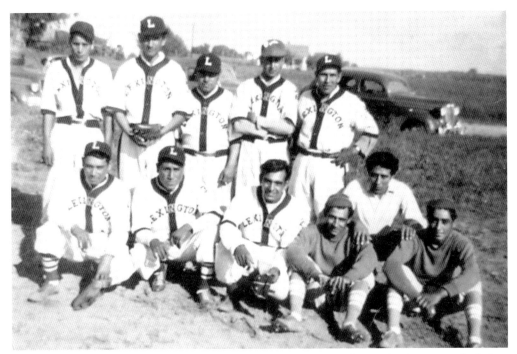

This photograph of the 1941 Lexington, Nebraska, team was taken only three months before the attack on Pearl Harbor. Most members of the team worked in the fields yet found precious time to practice during the week even when dead tired. Baseball was an escape from the hard life of work and discrimination. Like many of their generation, a few of these players served their country during World War II and the Korean War. (Courtesy of Lano Oropeza.)

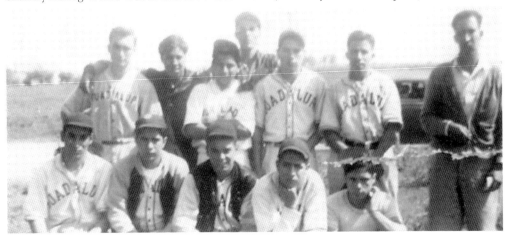

The 1941 Omaha Our Lady of Guadalupe Church team was managed by Lano Oropeza (standing far right). Mexican American baseball in Omaha, Nebraska, dates back to at least the early 1930s. Many of these players or family members worked in the slaughterhouses. The roster included Abbie, Camilo, Epifanio, and Isaias Alba, Tony Armenta, Leo Barajas, Manuel García, Eddie Gómez, Joe Juárez, Paul Márquez, Lano and Tom Oropeza, Ray Velásquez, coach Joe Ramírez, and batboys Massey Ochoa and Eddie Reyes. (Courtesy of Lano Oropeza.)

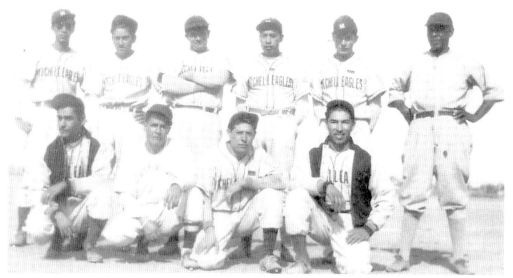

The Eagles from Mitchell, Nebraska, had one of their better teams in 1947, finishing as co-champions. A charter member of the Mission League in 1946, they went on to produce outstanding teams and players. Conrad Huerta and Senovio Reyes were instrumental in the organization of the Mission League. Pictured from left to right are (first row) Jerry Morin, Bart Zapata, Mariano Fonseca, and Joe Vega; (second row) Daniel Muro, Conrad Huerta, Senovio Reyes, Paul Núñez, Carmelo Reyes, and coach T. DeCory. (Courtesy of Isabel Ramírez.)

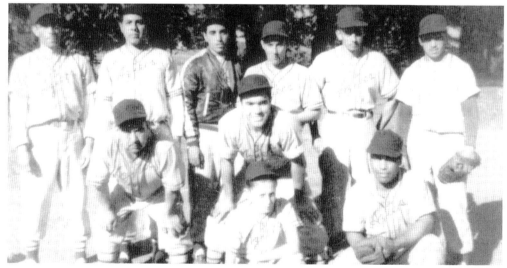

Silvis, Illinois, has a long and rich history of baseball and softball dating back to the early 1930s. The four major teams were the A.C.'s, Rebels, Aztecas, and Charros. This is the 1948 Aztecas. Pictured from left to right are (first row) batboy George Studen; (second row) Jesse Montéz, Tanilo Sandoval, and Pete Medina; (third row) Emidio Sandoval, Louis Ramírez, Tanilo Soliz, Julius García, Rubén Sandoval, and Alfonso López. Silvis is the home of the Hero Street National Memorial that pays tribute to the wartime sacrifices of local Mexican Americans. (Courtesy of Tanilo Sandoval and Joe and Benny Terronez.)

The first Mexicans arrived in Silvis, Illinois, in 1908 and in Bettendorf, Iowa, in 1915. By the end of the 1920s, nearly 65,000 Mexicans were residing in the Midwest, with an additional 16,000 mostly from Texas working the summer months. The members of this Silvis 1950s team are, from left to right, (first row) John Nache, Richard Esperza, Matt Reyes, Guady Medina, Larry Vallejo, and Jesse Medina; (second row) Steve Terronez, Tony Martel, David Rangel, Al López, Bob Moreno, Gonzalo López, Ted Nache, and Sonny Vallejo. (Courtesy of Tanilo Sandoval and Joe and Benny Terronez.)

The League of United Latin American Citizens (LULAC) is a national organization that formed a chapter in Davenport, Iowa, promoting civil, political, economic, and educational equality. The chapter formed ball clubs. The members of this LULAC team are "Coachie" Pea, Manny Salas, Lyle Peña, Mike Ramírez, Kenny Jackson, Francisco McQuay, Alvino Peña, Lupe Bernal, Dick Castro, Rick Salas, Jesús Peña, Bill Davenport, Joe Peña, Bob Reyes, and John Reyes. They played in the Mexican League at Credit Island in Davenport. (Courtesy of Rick Salas.)

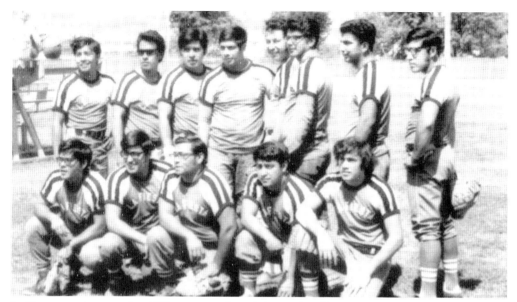

La Fiesta members on this 1971 team are, from left to right, (first row) Joe López, Leonard López, John Nache, Ralph Ramos, and Joe De La Rosa; (second row) Rudy Ramos, Boss Rangel, Louis López, G.G. Sierra, Joe Peña, Jim Sierra, Paul Sierra, and Dave López. The team was sponsored by a restaurant/bar in East Moline, Illinois. There were other teams in the league, including Fernández Auto Sales, LULAC Council No. 10 from Davenport, Iowa, and El Povito from Moline, Illinois. (Courtesy of Goody Ramos.)

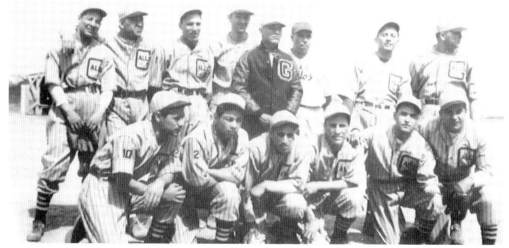

Los Gallos of East Chicago, Indiana was a powerhouse team from the Mexican American harbor community from the 1930s through the 1950s. They played Negro League teams including the Kansas City Monarchs, the New York Cubans, and the Chicago American Black Giants. From left to right are (first row) Cipriano Hernandez, Jose M. Gonzalez, Jose Alamillo, Leo Hernandez, Felix Perez, and Peter Jurassevich; (second row) Trini Castillo, Angelo Machuca, Benny Ortega, John Jurrassevich, manager Jose Flores, Florcencio Soto, Fred Luna, and Henry Machuca. (Señoras of Yesteryear.)

FIELD OF DREAMS

From its humble beginnings, the Latino Baseball History Project has been exceptionally fortunate in the incredible support of former players and their families, neighbors, and friends. The heart and soul of the project comes directly from the players and their supporters who have contributed amazing photographs, astounding stories, and precious memorabilia. Since its inception, the project's mission and policies have been to provide diverse venues to help players document and write their own history and the history of their communities. In 1968, *El Plan de Santa Barbara* laid out the vision and framework of Chicano research. The plan consisted of several critical parts, including providing opportunities for working-class Mexican American people to finally tell their own stories. In our ongoing book series on Mexican American baseball and softball, major themes have emerged as people have recounted past events related to ball, including discrimination and prejudice, civil and political rights, class struggle, gender independence, service to country, language autonomy, cultural legitimacy, and the importance of sports in uniting generations of families.

This research has revealed critical parts of Chicano and Chicana history that had not yet been fully explored, including the role that softball played in the private, public, and community lives of women; the impact on the lives of men who played ball in the military, especially during wartime; the immense role that baseball and softball played in the civil and labor rights movements; how language and culture were reaffirmed on the diamond; the social connection between urban renewal and the decline of barrio ball; and how baseball and softball networks evolved into familial networks and gradually into political networks that later led to the election of Mexican Americans at the local, state, and national levels especially after World War II.

In each of our previous four books, the last chapter pays tribute to some of the players and their families who have lend their boundless energy to recapture yesteryear so that future generations will have both an understanding and pride knowing that their forbearers made major contributions to the development of this country both on and off the ball field.

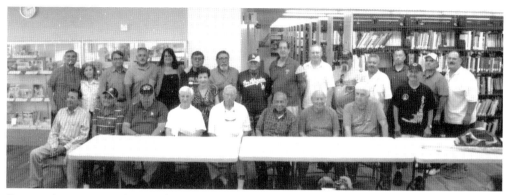

During the summer of 2013, the Ethnic and Women's Studies Department and the Cesar E. Chávez Center at California State University at Pomona and the Latino Baseball History Project at California State University at San Bernardino hosted an exhibit saluting Mexican Americans who played ball in the military, especially during World War II, the Korean War, and the Vietnam War. Nearly 50 players were highlighted in the exhibit. On September 4th, a luncheon and first-pitch ceremony were held. The players and family representatives posed for a group photograph. (Courtesy of the Latino Baseball History Project.)

A book-signing event was held in Riverside, California. Many of the individuals in this photograph had family members, especially fathers, uncles, and grandfathers, who played baseball in Kansas, Missouri, Colorado, and Wyoming from the 1930s through the 1950s, including Sam Amador and Patricio Estrada, Pictured from left to right are (first row) Susie Caney, Phyllis Pérez, Rudy Amador, and Robert Amador; (second row) Jonathan De La Cruz, John Chairez, Beverly Chairez, Margret Santiago, Lazaro Santiago, Lizic Luna, David De La Cruz, and Becky Jiménez. (Courtesy of the Latino Baseball History Project.)

The Gómez family has produced several outstanding players. Tony Gómez grew up in Claremont and is considered one of the best players of his era. Tony earned a Bronze Star during World War II while serving in the Pacific. He and his brother Paul helped their teams win several league and tournament championships. Seen here holding Tony's jersey when he played for Claremont Nursery are, from left to right, his children Kenny Gómez, Rudy Gómez, Roseanne García, and Elizabeth Cárdenas. (Courtesy of Rudy Gómez.)

In December 2013, Ramona Cervantes hosted a book-signing event in Arleta, located in the San Fernando Valley. Several former players and their families attended the event. Cervantes (first row, third from left) played for the Vixies, a Mexican American women's team, and at North Hollywood High School in the 1940s. Her late husband, Joseph, coached Little League, Pony League, and Park League. Her daughter Yolanda and sons Manuel and Joey also played ball. They are now a fourth generation of family players. (Courtesy of the Latino History Baseball Project.)

For the five past years, a game is played in memory of Lipe Hernández, who was an outstanding player from Catalina Island. Over 150 family members and friends pay tribute and honor Lipe, who taught nearly three generations of family the art of baseball and softball. Teresa McDowell, a daughter of Lipe, helps organize both the ball game and dinner each August. Teresa was the first girl to play Little League for the Lions in 1970 and made the high school baseball team. (Courtesy of Teresa McDowell.)

This photograph represents three generations of the Félix family in Claremont. From left to right are Rudy, Jerry, Ignacio, and Gabriel. Gabriel played two years of Little League baseball in Claremont, starting in 1985 with the Buffalos. The following season he played for the Giants as a shortstop and pitcher. Gabriel has been playing outfielder for 12 years for an adult men's team. There are families in the Pomona Valley with three, four, and five generations of players dating back to the 1920s. (Courtesy of Rudy Félix.)

Enrique M. López (left) and brother Victor M. López (not shown) played organized youth baseball through high school in Ontario. Their father, Severin R. López (center), is a native of Ontario and played for various baseball and softball teams in the 1940s until he was drafted into the Army. He was a decorated soldier during the Korean War. Nicolás López (right), son and grandson, respectively is a highly regarded elite travel team player in Southern California. (Courtesy of Enrique M. López.)

The five De La Rosa brothers of East Los Angeles have played ball as long as they can remember. Their collective experiences include youth ball, high school, community college, and military ball. They are seen here with their family team, Los Indios. They graduated from Roosevelt High School in Boyle Heights. Their occupations included education, coaching, and firefighting. Pictured from left to right are (first row) Al; (second row) Frank and Refugio; (third row) Elías Jr. and Rubén. (Courtesy of Al De La Rosa.)

BIBLIOGRAPHY

Alamillo, José M. "Playing Across Borders: Transnational Sports and Identities in Southern California and Mexico, 1930–1945." *Pacific Historical Review* 79 (3): 360–392. University of California Press, 2010.

Iber, Jorge. *Mike Torrez: From the Barrio to the Majors*. Unpublished manuscript, 2014.

Klein, Alan M. *Baseball on the Border: A Tale of Two Laredos*. Princeton, NJ: Princeton University Press, 1997.

Ledesma, Alfonso, and Alejo L. Vásquez, *A Short History of Mexican American Baseball In Rancho Cucamonga, 1930–1980*. Unpublished manuscript, 2014.

López, Enrique M. "Community Resistance to Injustice and Inequality: Ontario, California 1937–1947." *Aztlán* (Fall 1986): 1–29.

———. "Chicano Anglo Relations in Ontario, California, 1937–1947." Unpublished paper, June 1984.

Moline Dispatch Publishing Company. *The Home Team: Sports Memories of the Quad-Cities, 1920s–1960s*. Moline, IL: Moline Dispatch Company, 2005.

National Hispanic Cultural Center of New Mexico. *Barelas a Través de los Años: A Pictorial History*. Albuquerque: National Hispanic Cultural Center, 2010.

O'Reilly, Jean, and Susan K. Cahn. *Women and Sports in the United States: A Documentary Reader*. Boston: Northeastern University Press, 2007.

Ruiz, Vicki. *From Out of the Shadows: Mexican Women in Twentieth-Century America*. New York: Oxford University Press, 1998.

Santillán, Richard A. *From the Battlefields to the Ballfields: Mexican Americans and Military Ball: World War II, Korea, and Vietnam*. Unpublished manuscript, 2014.

Santillán, Richard A., et al. *Mexican American Baseball in the Central Coast*. Charleston, SC: Arcadia Publishing, 2013.

Sutter, L.M. *New Mexico Baseball Miners, Outlaws, Indians, and Isotopes, 1880 to the Present*. Jefferson, NC: McFarland & Co, 2010.

Torres, Noe. *Baseball's First Mexican-American Star: The Amazing Story of Leo Najo*. Coral Springs, FL: Llumina Press, 2006.

Uribe, Sandra. *Una Liga of Their Own: Mexican American Women and the Struggle for Gender Equality on the Diamond, 1930s–1960s*. Unpublished manuscript, 2014.

Vásquez, Louis, and James B. Lane. *Weasal: The Autobiography of Louis Vásquez*. Gary, IN: Indiana University Northwest, 1995.

ABOUT THE ORGANIZATION

History Project Advisory Board

Advisory board members for the Latino Baseball History Project at California State University, San Bernardino, include the following:

 José M. Alamillo, associate professor, California State University, Channel Islands
 Gabriel "Tito" Ávila Jr., founding president and CEO, Hispanic Heritage Baseball Museum, San Francisco
 Francisco E. Balderrama, professor, California State University, Los Angeles
 Tomas Benítez, artist and art consultant
 Anna Bermúdez, curator, Museum of Ventura County
 Raúl J. Cordoza, dean, Los Angeles Trade-Technical College
 Christopher Docter, graduate student, California State University, Northridge
 Peter Drier, professor, Occidental College
 Robert Elias, professor, University of San Francisco
 Luís F. Fernández, public historian
 Jorge Iber, associate dean and professor, Texas Tech University
 Alfonso Ledesma, Cucamonga public historian
 Enrique M. López, University of California at Riverside
 Susan C. Luévano, librarian, California State University, Long Beach
 Amanda Magdalena, doctorate student in history, University at Buffalo, the State University of New York
 Douglas Monroy, professor, Colorado College
 Carlos Muñoz Jr. professor emeritus, University of California, Berkeley
 Eddie Navarro, sports historian, Santa Maria
 Mark A. Ocegueda, doctorate student in history, University of California, Irvine
 Alan O'Connor, sports historian, Sacramento
 Gilberto Pérez, professor, California Baptist University, Riverside
 Samuel O. Regalado, professor, California State University, Stanislaus
 Anthony Salazar, Latino Baseball Committee, Society of American Baseball Research
 Richard A. Santillán, professor emeritus, California State University, Pomona
 Carlos Tortolero, president, Mexican Fine Arts Center Museum, Chicago
 Sandra L. Uribe, professor, Westwood College, South Bay Campus, Torrance, California
 Alejo L. Vásquez, Cucamonga public historian
 Angelina F. Veyna, professor, Santa Ana College
 Alfonso Villanueva Jr., Arbol Verde Committee, Claremont

Planning committee members for the Latino Baseball History Project include the following:

 Cesar Caballero (chair), Iwona Contreras, Richard A. Santillán, Terry Cannon, Tomas Benítez, Mark A. Ocegueda, Cherstin Lyon, Jill Vassilakos-Long, and Manny Verón.

Discover Thousands of Local History Books
Featuring Millions of Vintage Images

Arcadia Publishing, the leading local history publisher in the United States, is committed to making history accessible and meaningful through publishing books that celebrate and preserve the heritage of America's people and places.

Find more books like this at
www.arcadiapublishing.com

Search for your hometown history, your old stomping grounds, and even your favorite sports team.

Consistent with our mission to preserve history on a local level, this book was printed in South Carolina on American-made paper and manufactured entirely in the United States. Products carrying the accredited Forest Stewardship Council (FSC) label are printed on 100 percent FSC-certified paper.